easel does it
Calligraphy

nancy ouchida-howells

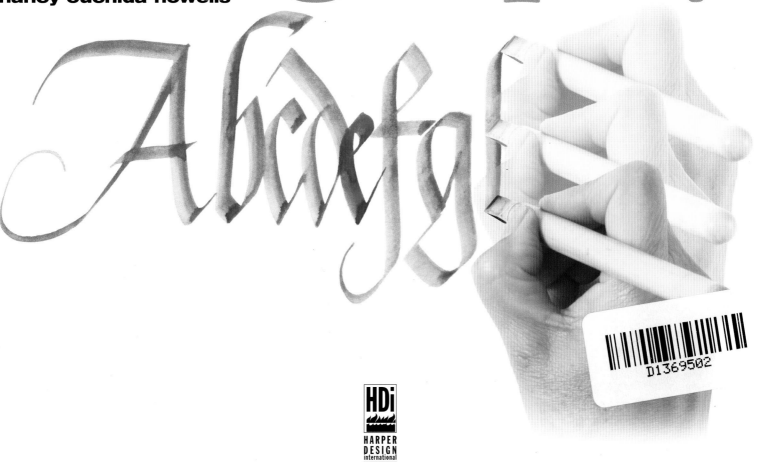

HARPER DESIGN international

An Imprint of HarperCollinsPublishers

index

PICTURE CREDITS

The pictures used on pages 3 and 4 were supplied by Topham Picturepoint, P.O. Box 33, Edenbridge TN8 5PF, U.K.

ACKNOWLEDGMENTS

The author would like to thank all her teachers and pupils from whom she has learned so much; David Howells, who has advised on, and helped correct, the copy; and all those at Axis Publishing for their hard work.

CALLIGRAPHY: EASEL DOES IT
Copyright © 2004 by Axis Publishing Ltd.

First published in the United States in 2004 by
Harper Design International
An imprint of HarperCollinsPublishers
10 East 53rd Street
New York, NY 10022
www.harpercollins.com

Created and conceived by
Axis Publishing Limited
8c Accommodation Road
London NW11 8ED
UK
www.axispublishing.co.uk

Creative Director: Siân Keogh
Editorial Director: Brian Burns
Managing Editor: Conor Kilgallon
Design: Axis Design Editions
Production Manager: Tim Clarke
Photographer: Mike Good

HarperCollins books may be purchased for educational, business, or
sales promotional use. For information, please write: Special Markets
Department, HarperCollinsPublishers Inc., 10 East 53rd Street, New
York, NY 10022.

First edition

Printed and bound in Thailand

1 2 3 4 5 6 7 / 10 09 08 07 06 05 04

Library of Congress Cataloging-in-Publication Data

Ouchida-Howells, Nancy.
 Calligraphy : easel does it / Nancy Ouchida-Howells.
 p. cm. -- (Easel does it)
 ISBN 0-06-058834-9 (covered wire)
 1. Lettering--Technique. 2. Calligraphy--Technique. I. Title.
 II. Series.
 NK3600.O83 2004
 745.6'1--dc22

 2003018584

contents

When studying calligraphy, it is useful to enroll in a calligraphy class or belong to a society. Here is a list of some of the larger calligraphy societies, many of which publish a newsletter and hold slide programs and workshops.

U.S.A.
CALIFORNIA
Friends of Calligraphy
P.O. Box 425194
San Francisco, CA 94142-5194
www.catalog.com/gallery/FOC.html

Society for Calligraphy
P.O. Box 64174
Los Angeles, CA 90064-0174
SfCPresDS@aol.com

ILLINOIS
Chicago Calligraphy Collective
P.O. Box 11333
Chicago, IL 60611-0333
www.chicagocallig.com

MINNESOTA
Colleagues of Calligraphy
P.O. Box 4024
St. Paul, MN 55104-0024

MISSOURI
St. Louis Calligraphy Guild
P.O. Box 16563
St. Louis, MO 63105-1063

NEW YORK
Society of Scribes, LTD.
P.O. Box 933
New York, NY 10150-0933

TEXAS
The Dallas Calligraphy Society
422 Provincetown Lane
Richardson, TX 85080-3421

San Antonio Calligraphers Guild
P.O. Box 291232
San Antonio, TX 78229-1832
www.axs4u.net/home/inksmith/sacg.htm

VIRGINIA
Washington Calligraphers Guild
P.O. Box 3688
Merrifield, VA 22116-3688
www.calligraphersguild.org

AUSTRALIA
Australian Society of Calligraphers
P.O. Box 190
Willoughby, NSW 2068

Calligraphy Society of Victoria Inc.
G.P.O. Box 2623W
Melbourne, Victoria 3001
www.alphalink.com.au/-callivic

CANADA
Alphabeas Calligraphy Guild
20025 36th Avenue
Langley, British Columbia
V3A 2R5
www.geocities.com/theabcguild

Bow Valley Calligraphy Guild
P.O. Box 1647 – Station M
Calgary, Alberta
T2P 2L7
www.bvcg.ca

Calligraphic Arts Guild of Toronto
c/o Neilson Park Creative Centre
56 Neilson Drive
Etobicoke, Ontario
M9C 1V7
calligraphicarts.tripod.com

Edmonton Calligraphic Society
P.O. Box 336, 9768
107th Street
Edmonton, Alberta
T5T 4L4
www.freenet.edmonton.ab.ca/edmcalli

Fairbank Calligraphy Society
P.O. Box 5458
Victoria, British Columbia
V8R 6S4

Lettering Arts Guild of Red Deer
P.O. Box 242
Red Deer, Alberta
T4N 5E8

Northern Lights Calligraphers
186 Wolverine Drive
Ft McMurray, Alberta
T9H 4L7

Westcoast Calligraphy Society
P.O. Box 18150
2225 W 41st Avenue
Vancouver, British Columbia
V6M 4L3
www.geocities.com/Paris/Lights/8989

CHINA
Alpha Beta Club
P.O. Box 73615, Kowloon Post Office
Kowloon, Hong Kong
www.geocities.com/soho/gallery/4143

Hong Kong Lettering Arts Club
Connaught Commercial Bldg.
185 Wanchai Road, Room 901
Wanchai, Hong Kong

U.K.
Calligraphy & Lettering Arts Society
54 Boileau Road
London SW13 9BL
www.clas.co.uk

Society of Scribes & Illuminators
6 Queen Square
London WC1N 3AT
www.calligraphyonline.org

SOUTH AFRICA
The Calligraphy Association
P.O. Box 92189
Norwood 2117, Johannesburg

Cape Friends of Calligraphy
P.O. Box 23126
Claremont 7735, Cape

Pendance Calligraphy Guild
P.O. Box 21620
Helderkruin 1733, Gauteng Province

JAPAN
Japan Calligraphy School
2–36, Inaoka Bldg.
Kanda-Jinbocho, Chiyoda-ku
Tokyo 101-0051

introduction

All writing has evolved from art. The earliest known records of human activity are the pictures that cave dwellers drew on the walls to commemorate the hunt. Gradually, over 20,000 years, pictures became simplified in form and more symbolic, such as the pictograms or ideograms of the Sumerian cuneiform writing system and Egyptian hieroglyphics. The first Western alphabet representing phonetic sounds was written on clay tablets by the Phoenicians about 2000 BC. As the centers of power shifted around the Mediterranean, the Greeks, Etruscans, and, later, the Romans modified the alphabet to comprise 23 of the letters that we recognize today. Later, as written language developed, the letters "J," "U," and "W" were added.

parchment and pen

The Romans used three different writing scripts: a stylus on wax tablets and clay; a chisel on stone to carve the classic capitals—beautifully proportioned and still an inspiration—on monuments and public buildings; and a chisel-shaped brush or reed to write the rustic capitals. As the armies of Rome spread across the world, so too did Roman literature. In 311 AD, the Emperor Constantine began urging the spread of Christianity. The Bible became the first codex bound as a book, made with parchment or vellum pages, written with a quill in the round circular uncial hand (a curved hand of unequal height as used in Greek and Latin manuscripts). The Irish developed a half-uncial hand and wrote the *Book of Kells*, and the *Lindisfarne Gospels* were completed in 698 AD in Northumbria, U.K.

In 789 AD, Charlemagne, King of the Franks, wanted to unify many peoples, cultures, and languages under one language—Latin—and one writing script. He dispatched Alcuin of York, England, along with a team of scribes to Tours, France, to develop the Caroline minuscule, a clear rhythmic writing that remained the dominant script for centuries. The English monks who wrote the *Ramsey Psalter*, an elaborate 10th-century codex, developed the most legible script—the letters are round and clear and were later rediscovered by Edward Johnston in 1900. He modernized it and called it the "Foundation" hand.

As medieval architecture became taller, pointed, and more angular, the shape of letterforms such as gothic, blackletter, and texture came to reflect this fashion. Later, in the 15th century, Gutenberg made moveable type, which used gothic letterforms handcut from wooden blocks. This type was used in printing the first Western books. In the 20th century, letter and type designer Rudolf Koch carved blackletter shapes into metal, while today, Hermann Zapf designs digital fonts.

classic texts

As written correspondence became more widespread, a faster form of writing had to be found. In the 16th century, the italic hand was developed using an elliptical "o" and a greater economy of movement that allowed letters to be joined together. Among others, Lodovico Arrighi (1520) and Giovanni Battista Palatino (1544) wrote copybooks that inspire us as much today as they did their royal patrons at the time. This popular calligraphy has many variations—chancery cursive, formal, flourished, compressed, pointed, swash, handwriting, sharpened, gothicized—and is now used internationally.

To cope with ever greater demands for printing, the copperplate replaced wood-cut blocks and mass printing closed many scriptoria. The new form of engraving used a pointed tool called a burin to incise the copper and it became possible to print more copies with finer detail on paper. The pointed, flexible metal pen now replaced the 1,500-year-old broad-edged quills and reeds.

Greek codex, 4th century. Codex is the earliest form of book, written with a quill on pages made from parchment (sheep- or goatskin) or vellum (calfskin). The pages were bound between wooden boards.

At the end of the 19th century, William Morris, concerned that many traditional skills would be lost, started the Arts and Crafts Revival in Britain. His secretary, Sydney Cockerell, encouraged Edward Johnston to study medieval manuscripts in the British Library. Johnston rediscovered the broad-edged pen and writing techniques of the medieval scribes. In 1899, he gave the first "lettering" class in the world and, in 1906, published *Writing, Illuminating, & Lettering*, which is still in print today and is the most widely sold book on calligraphy. In 1916,

project 1 — place name and menu

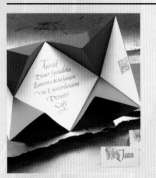

Menus and place names add a personal touch to a dinner party, birthday celebration, wedding reception, or other occasion. As well as being rewarding, it is practical to make your own menus and place names, as you can make them to fit into the color scheme of your table setting. Each guest will feel special when he or she finds his or her name written in calligraphy. The menus and place names are adorned with a stamp using gold metallic gouache.

project 2 — invitation

One of the delights of life is to invite your friends and family to a special occasion. What better way to create your invitation than by making your own words and design using calligraphy. When you receive a handmade invitation, you know it is something special.

project 3 — poem in your pocket

When you write words in calligraphy, it is a pleasure to share them with a special person. The poem in your pocket makes an ideal gift because it is unique and made with only one recipient in mind. The small, accordian-folded book is an attractive project that can be created by calligraphers at all levels. A poem in your pocket is a pleasure to create and a precious thing to receive.

project 4 — photograph album cover

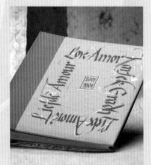

Calligraphy is a wonderful way to decorate the cover of an album filled with personal photographs. Its striking, bold design is the perfect way to personalize and identify the contents of the album. The cover title can be decorated with the names of family members, friends, special holiday destinations, or a personal interest. In the example illustrated, the title "love" is written in several languages.

project 5 — family tree

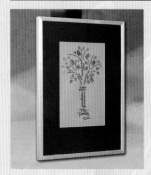

Each family is unique and creating a family tree makes sense of the history behind it. The tree should have family names, but you can embellish it with dates, descriptions, and even photographs and drawings. This project is illustrated as a "living tree" and is designed to show a single line of descent and the relationships among family members. This is a guide that can be used by any family.

project 6 — wrapping paper, gift tag, and greeting card

In this project, you will discover how to make beautiful personalized wrapping paper with matching gift tag and accompanying greeting card. This will make the preparation and giving of gifts even more special, and delight friends and family on birthdays, anniversaries, christenings, and other important occasions.

project 7 — scrapbook cover

Enhance your scrapbook cover with your own handwritten calligraphy and designs. In this project, you can match your calligraphy to a theme—in this case, spring. However, you can decorate your cover to tell your own story or commemorate an occasion, using any calligraphic style, size, or paint or ink color. This project will also help you learn about layout and presentation.

project 8 — trinket box

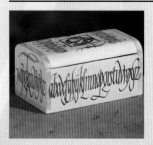

Write a little calligraphy to decorate a small wooden box and create a treasure. The initials or monogram can be those of a special person or the lid can be decorated with the name of a memorable event or date. The project is quite unique as the calligraphy is written flat, then pasted on to a three-dimensional box. This thoughtful box can be used to hold a small, special treasure.

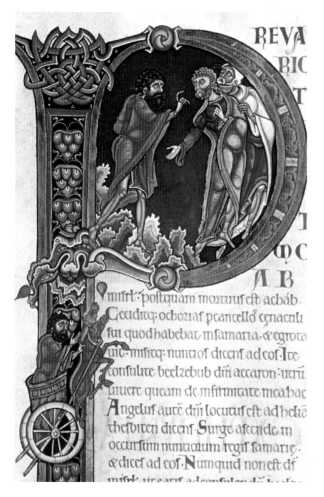

Johnston was commissioned to design lettering for London Transport's subway and buses. This letter style became the first sans-serif type.

The present revival of calligraphy across the globe owes much to Johnston's genius, philosophy, and masterly use of the broad-edged pen, reminding us all that writing by hand, in a beautiful style, is both rare and precious.

calligraphy today

Calligraphy is, quite literally, beautiful writing. The word itself comes from the Greek *kallos*, meaning beauty, and *graphia*, meaning drawing or writing.

Most people take up calligraphy because they want to create something with their hands. Art classes, such as drawing, may feel somewhat daunting, whereas writing, which we all learned at school, feels more attainable; you don't have to be particularly artistically talented to enroll in a class.

Calligraphy is an interesting and deeply satisfying activity. The materials—pen, ink, and paper—are relatively inexpensive. Beautiful writing has practical applications, too, such as addressing envelopes, and making cards for birthdays, anniversaries, graduations, and so on. It can also be used, as it has been throughout the centuries, to add names to certificates, awards, diplomas, marriage certificates, and family trees. Making gifts, such as boxes and decorated books, is another application, as is more formal work such as creating pieces of art by combining words and images for exhibition purposes.

Calligraphy's status in the Western world as a recognized, genuine artistic activity is growing fast, while in the Orient, it is respected as the highest art form. Writing beautifully is increasingly popular throughout the world (see p. 95 for a list of useful addresses and links).

Calligraphy invites you to find the perfect words. Whether it is poetry, stories, jokes, a few favorite lines from a play, novel, or a song, words come to life with a calligrapher's pen. A whole

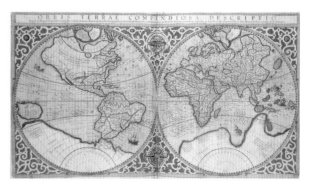

A 16th-century Mercator map, named after the famous cartographer, Gerhardus Mercator.

Mercator's maps were masterpieces of intricate design and calligraphy.

new world opens up as we explore our thoughts and memories, as well as the canons of literature, in search of the right words.

Many people use calligraphy to express their thoughts and feelings and connect with their inner self. By committing these personal thoughts to a diary, letter, journal, or scrapbook, they can share them with others.

Calligraphy is also ideal for personalized letters and greeting cards. Imagine a person going to the mailbox and their excitement at seeing the package they've just received. Though the words are to be read and enjoyed, a great deal more is being communicated. The card design, choice of paper, style of calligraphy, and colors all deliver the message: "I care enough about you to spend the time and effort to make this."

Calligraphy also brings a sense of inner calm. The physical act of holding a pen and feeling it move across the paper is a unique pleasure. Writing, drawing, and painting demand full attention and concentration, a balance between control and freedom that creates a meditative, peaceful state as you immerse yourself in the act of creating. So pick up your pen and lose yourself in this beautiful activity.

A page from the Winchester Bible, created in England c.1160–1180. It was written by one scribe on 468 pages of parchment and illuminated with 54 large initials,

such as the letter "P" shown here, which were drawn by at least six different artists. It remains today in the library of Winchester Cathedral.

27 This box has a curved lid, so take great care to align the edges of the paper with the calligraphic lettering to the edge of the lid. Starting from the center, press gently toward the edges to remove any air bubbles and flatten the paper to the wood.

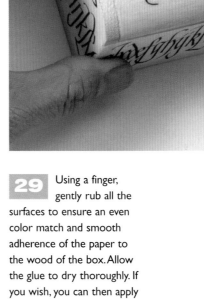

28 To match the color of the white tracing paper to the wood of the box, select a matching pastel. Rub it on a paper towel or a piece of soft cloth, and rub the color onto the tracing paper.

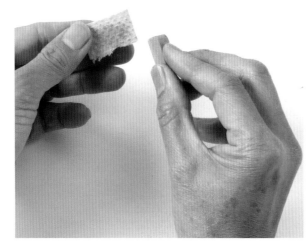

29 Using a finger, gently rub all the surfaces to ensure an even color match and smooth adherence of the paper to the wood of the box. Allow the glue to dry thoroughly. If you wish, you can then apply varnish or shellac to the box.

materials and equipment

The materials used in calligraphy are easy to obtain, set up, and maintain, and compared to other arts—such as painting, enameling, pottery, or weaving—are relatively inexpensive. The most basic equipment is a pen point (or "nib"), a penholder, ink or paint, paper, and a brush.

pens

There is a wide variety of pens available for writing calligraphy. The simplest ones are called calligraphy (or lettering) "dip" pens. These usually come in two parts—a detachable (or loose) pen point and a penholder.

Pen points are rectangular in shape and are called broad-edged pens. They are cut at different angles: square or horizontally, right oblique, or left oblique (see illustrations below). Many right-handed calligraphers use both the square-cut and right-oblique pen points, depending on the writing style. Try out different pen points to discover what works well for you.

All the broad-edged pen points write a wide variety of alphabet styles, including uncials, versals, Carolingian, foundational, gothic, blackletter, bâtarde, italics, legende, neuland,

Square-cut points are used by many right-handed calligraphers as well as some left-handers.

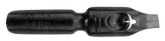

Left-oblique points are used by most left-handed calligraphers. They are also ideal for writing the Arabic script.

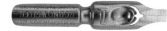

Right-oblique points are used by right-handed calligraphers.

pen-written Roman capitals, compressed hand, and modern inventive alphabets. Whichever pen point you choose, wash it with a little soap and water before using it. After using a pen, always clean it by rinsing it in clean water and wiping it dry with a rag or paper towel.

reservoirs

Reservoirs help to control the flow of ink or paint through the pen. They take the form of a piece of wedge-shaped metal adjacent to the pen point that "holds" the ink or paint using the surface tension of the liquid. Some manufacturers, such as Speedball, Hiro, or Brause, make pens with an attached reservoir. Others make pens with a loose reservoir ("dip" pens) that needs to be fitted or slipped onto the pen before you can start filling it with ink or paint.

A Speedball pen with a brass reservoir attached. The reservoir creates a wedge-shaped space into which ink, gouache, or watercolor paint is added using a brush or pipette.

Some calligraphers prefer to "dip" their pens into the ink bottle or palette of paint but this may result in the first strokes having too much ink or paint.

MAKING AND FILLING A RESERVOIR

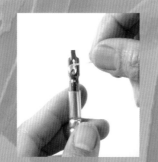

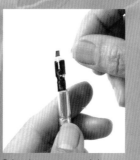

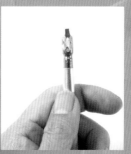

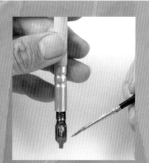

Cut a very thin strip of masking tape about ⅛in (3mm) wide and 1in (2.5cm) long. Stick the tape onto the pen point, starting on the top side.

Bring the tape around the underside of the pen. Take care that the tape does not stick to the underside but creates a "pocket" for the ink.

Rotate the pen so that the upper side of the nib is facing you and press the tape down firmly to stick it on.

Using a cheap brush or pipette, fill the reservoir with ink, gouache, or watercolor paint and start writing.

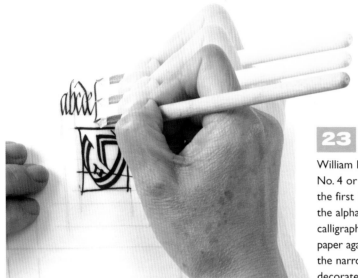

23 Rotate the paper and, using a William Mitchell pen No. 4 or equivalent, write the first 13 letters of the alphabet in a narrow calligraphic style. Turn the paper again and finish writing the narrow letters to decorate the lid of the box.

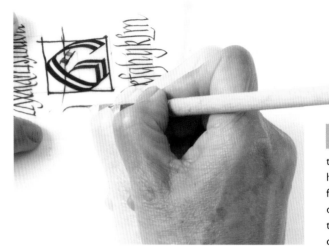

25 To fill the space above and below the letter "G," add a horizontal line for the flourish. Let the calligraphy dry completely and cut the tracing paper to the size of the box lid.

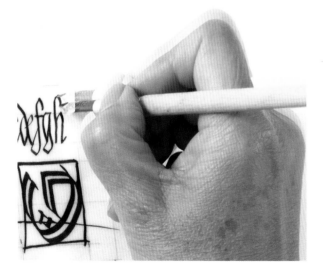

24 The exciting aspect of this box project is that you can choose what words, letters, and patterns you would like to use on the box; it could be very simple or, if you prefer, highly decorative.

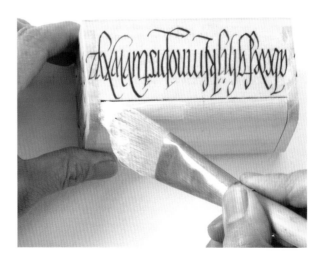

26 Carefully apply PVA glue to the box with a stiff brush or use spraymount. Take care not to get paste on any of the writing. If you use spraymount, spray the paper first, then fix it to the wooden box.

FITTING A READY-MADE RESERVOIR

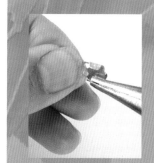

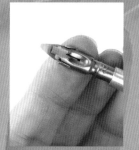

If the reservoir is too tight, use pliers to open the clips; this will help the reservoir to slip onto the pen point. Also check that the pressure of

the reservoir does not open the slit in the pen point or distort its writing edge. If it does, be careful not to loosen it too much.

penholders

It is important to find a penholder that feels comfortable in your hand and there is a wide range to choose from: thin and wide diameters, short and long lengths, round and hexagonal shapes, heavy and light weights, and smooth and textured surfaces. With most penholders, a pen point is inserted at one end, but some are designed to have pen points inserted at both ends. If you prefer a wide diameter penholder, choose one with a finger grip; this will make it easier to hold.

Penholders are available in various shapes, lengths, and widths. A tapered barrel is shown above, and a wooden cylindrical barrel is shown below.

When inserting a pen point into the penholder, check to make sure that it fits snugly into the opening made for it. Pen points vary in size according to the manufacturer, as do the openings in penholders; a wobbly pen does not write well.

inks

The most convenient ink to use for calligraphy is a bottle of modern fountain pen ink. Water-soluble (non-waterproof) ink is best, as waterproof and acrylic inks tend to dry quickly and clog the pen point. Take care, however, that your ink does not absorb into the paper too much, resulting in soaked, "feathered" writing. Although there are many cheap brands available, it is worth buying a high-quality ink from an art shop.

Many experienced calligraphers use Chinese stick ink, which is ground down on a slate with water. If you choose this type of ink, dry the stick thoroughly after grinding or else it will crack and splinter into small pieces.

paints

Paints, rather than inks, are used to create color in calligraphy. Water-soluble paints, such as designers' or artists' gouache (an opaque watercolor), as well as more usual transparent watercolors, work well.

Good-quality gouache is made of finely ground pigment, gum arabic, water, and preservative. The paint flows easily through the pen point, resulting in bright, pure colors.

Ultramarine blue is a modern version of the medieval lapis lazuli color.

Vermillion red or scarlet lake is the traditional red used by scribes.

Oxide of chromium is the green color used in heraldry and medieval manuscripts.

Yellows are useful to mix with blue, red, and green to create further colors.

To start with, you will need only a few tubes of paint, such as ultramarine blue, scarlet lake (or another good red), a green, and a yellow, as these colors can be mixed to produce others.

Watercolors are ideal for multilayered writing, as shown in the Wrapping Paper, Gift Tag, and Greeting Card project (see pp. 65–74), and are sold as half pans, whole pans, and in tubes. Most gouache is sold in tubes.

To mix paints, squeeze a small amount from each tube onto a palette or into a small pot. Using a pipette or a cheap brush, add drops of water, mixing the paint until it reaches a milky consistency. You can also create a thicker "cream" or a thinner "water" consistency by adding less or more water.

19 After pasting all four sides of the box with the calligraphic lettering, carefully cut off any excess paper with a scalpel, craft knife, or scissors. Hold the paper up and cut as closely to the edge of the box as possible, without cutting the box. The writing on the sides of the box is now finished.

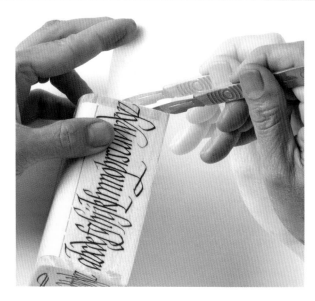

21 Using an Automatic pen No. 9 or double-line equivalent, write the letter "G."

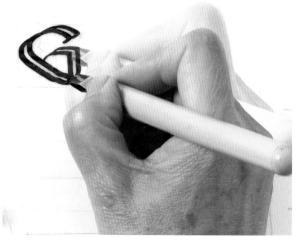

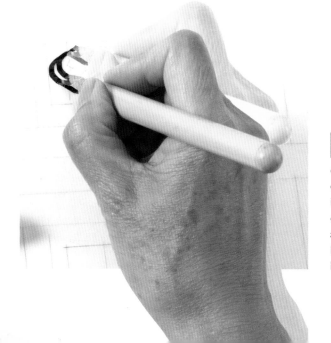

20 To complete the calligraphy and design on the lid or cover of the box, draw pencil lines indicating the shape of the lid, the writing lines, and the position of the letter "G" on a piece of heavyweight tracing paper.

22 Let the "G" dry completely. Then, add a vertical line through the curve of the letter. Extend this line into a box.

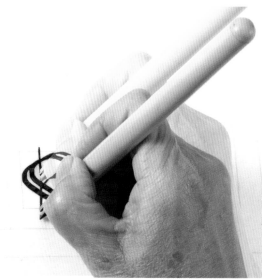

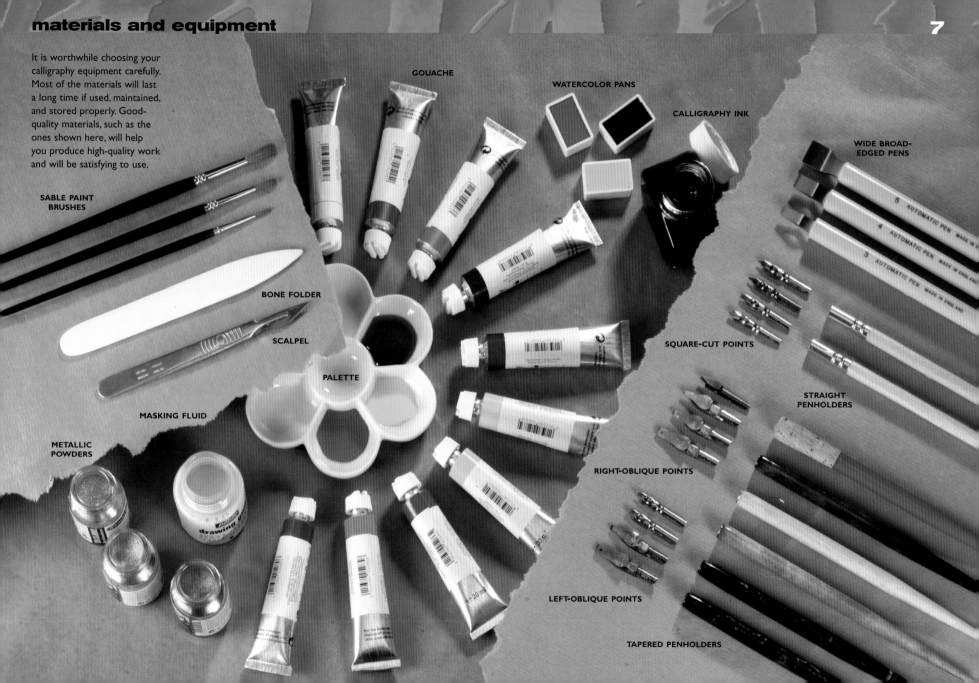

It is worthwhile choosing your calligraphy equipment carefully. Most of the materials will last a long time if used, maintained, and stored properly. Good-quality materials, such as the ones shown here, will help you produce high-quality work and will be satisfying to use.

GOUACHE

WATERCOLOR PANS

CALLIGRAPHY INK

WIDE BROAD-EDGED PENS

AUTOMATIC PEN · MADE IN ENGLAND

SABLE PAINT BRUSHES

BONE FOLDER

SCALPEL

PALETTE

SQUARE-CUT POINTS

STRAIGHT PENHOLDERS

MASKING FLUID

RIGHT-OBLIQUE POINTS

METALLIC POWDERS

drawing g

LEFT-OBLIQUE POINTS

TAPERED PENHOLDERS

16 When the paste is just tacky, but not wet, apply the tracing paper with the calligraphy to the correct side of the box. Watch the tracing paper to ensure that it does not buckle or bubble up as the paper expands due to the moisture of the PVA glue. If the PVA glue is too wet or if you have used too much, or the tracing paper is too thin, the paper will stretch too much and cause cockling or buckling.

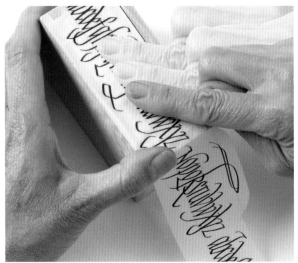

17 Place your finger in the center of the panel and gently smooth down the calligraphy tracing paper onto the box. Push out any air bubbles so that the side with glue adheres smoothly to the box.

18 Apply PVA glue or some spraymount to the next side of the box. Again, make sure that the application is even and very thin. Fold the calligraphy paper strip around the corner and gradually press down, starting from the center and working toward the edges.

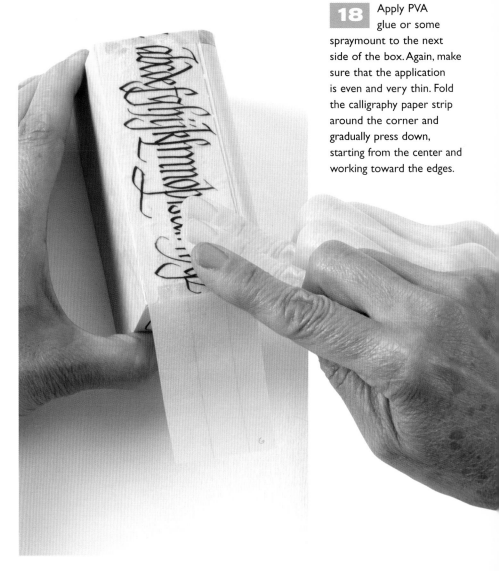

SABLE BRUSH NO. 6

SABLE BRUSH NO. 4

SABLE BRUSH NO. 1

brushes

For mixing paints and filling your pen, cheap brushes work well. But for painting, use a good-quality, short-haired sable or sable-nylon mix brush, size No. 2 or No. 3. Brushes also need to have a good point. It is important to clean the brush thoroughly in water after use and let the bristles or hairs of the brush dry naturally in the shape of a point.

masking fluid

Also known as drawing gum, masking frisket, or gum resist, masking fluid is applied using a standard pen point, but is designed to repel colors painted over the top of it. When the paint is dry, the fluid can be rubbed off, leaving the color of the paper underneath to form the design. Check that the consistency of the fluid is thin enough (like milk) to flow through a pen—some brands may be too thick. The Invitation project (see pp. 33–40) is one example of using masking fluid.

papers

Paper plays an important role in calligraphy and there is a wide variety of papers available to meet almost all creative needs. For beginners, "layout bond" is a useful practice paper. It is a white translucent paper that allows you to see a sheet of writing guidelines placed underneath it. More experienced calligraphers can draw writing lines directly onto the surface of the layout bond paper using an HB or 2B pencil. This paper is usually sold in pads and is available in a variety of sizes from

art shops. For more advanced work, there are thicker papers in a wide range including:

- Drawing paper, also called "cartridge" paper
- Watercolor papers, which are available in various weights and surface textures:
 Hot-pressed—a smooth surface
 Cold-pressed—a slightly textured surface (also called "NOT")
 Rough—a very textured surface
 Colored papers—in weights from light to very heavy
- Textured papers, from smooth (wove), lined (laid), to slightly rough, toothy finishes

The right type of paper is determined by what you want to create and the pens and ink or paint you are using. Always consider the paper's surface, color, texture, and weight. Some good-quality stationer's paper is appropriate for a handwritten letter, while a certificate or family tree requires paper that has

To try out the wide variety of papers on sale, purchase a paper sample book or a few sheets of paper and check that the ink or paint writes with crisp letterforms and does not bleed. Also, check that the ink or paint does not smear with erasures and that the paper does not cockle.

12 You can use several different, but related, styles with different flourishes, ascenders, and descenders to add variety to your work.

13 In this project, the calligraphy is written in one long strip, though you can use a single piece of writing, such as a quote. Using a scalpel, craft knife, or scissors, cut the tracing paper to a size slightly smaller than the box.

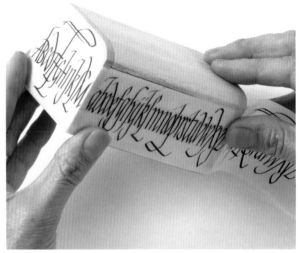

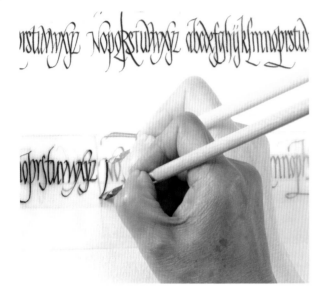

14 Hold the tracing paper with calligraphy right next to the box to check its length and height. Adjust any pieces of paper that are too big, and trim carefully to size.

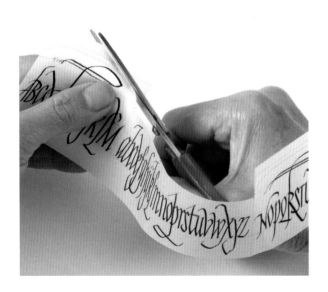

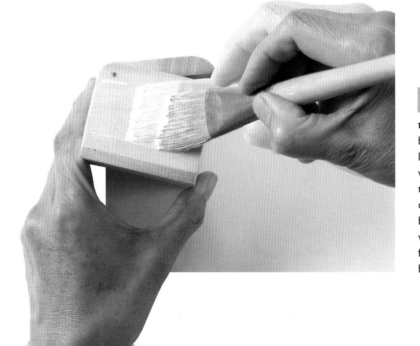

15 To paste the calligraphy paper to the box, use a stiff, clean brush to apply a very thin layer of PVA glue to the wood. Or you may prefer to use spraymount, in which case you should spray the back of the paper. It is worth doing a little test to find which method works best for you.

lasting qualities and that will not fade when exposed to light. A paper made of 100 percent archival cotton or rag paper would be suitable. Other projects, such as greeting cards and gift tags, need to be made from paper that has some weight and body so that it can be folded and left standing. Wrapping paper and book covers need to be thin enough to wrap but strong enough to be folded and written on.

The best way to find out about papers is to ask your teacher or friends which papers they use and try writing on some samples. Experimenting widely with a variety of papers will help you to gain experience and confidence.

It is always worth using good-quality paper. Sharp strokes of your pen should create crisp letterforms, whether writing thick or thin lines. The letters should not "bleed," which occurs when the ink or paint absorbs too readily into the paper, resulting in fuzzy, feathered strokes. Nor should the paper be so highly polished that the ink or paint is repelled.

writing board and workspace

A writing board is your work surface and is usually a piece of flat, smooth plywood approximately 24in (60cm) x 18in (45cm) x ⅜in (8mm). This type of wood can easily be purchased at a hardware store. Alternatively, an old scrap piece of wood will suffice.

Put the board on a table, and prop up the far edge with a box to create a comfortable angle for writing. Alternatively, while sitting down, prop the board between your lap and the edge of a table. Another way is to buy an adjustable table easel that sits on the table. When creating small pieces of work, use the easel at a steeper angle; when working on larger pieces, write with the board flat and stand over your work.

If possible, work in natural light. Also, an adjustable desk lamp is an essential piece of equipment, but make sure the light does not reflect straight back into your eyes. Use a T-square (see picture below) with your writing board along with a triangle (set square) when drawing guiding pencil lines to ensure that your work is straight. A metal ruler with a cork or non-skid grip is essential for measuring and for providing an edge to cut against when using a scalpel or craft knife.

Use a T-square to draw writing guidelines. Press the T-square firmly against the edge of your work surface with one hand while drawing lines with the other.

A metal edge is less likely to be damaged by the blade than a plastic one. Finally, sit on a comfortable chair. If possible, use an office chair that has adjustable height and back support.

writing cushions

Writing on a piece of paper that has been placed directly on the board creates a hard, unforgiving surface for the pen and tires the hand easily. The pen is a flexible tool and writes best if there is a cushion under the paper. There are various materials that can be used to provide a cushion:

• Thick, soft, unfolded, flat blotting paper
• Suede leather
• Felt fabric

Because your writing board will often be positioned at an angle, masking tape is useful for fixing your work onto the board. Tape the blotting paper, guard sheet, layout paper, and work in progress to the writing board, so that it is held in the correct position.

scalpels and craft knives

The craft knife (or utility knife) is used for cutting paper and cardboard. For cutting in and around letters or small areas, a craft knife or scalpel is best as it can cut around corners more easily. Paper dulls the blade surprisingly quickly, so you will need a sharpening stone to put the cutting edge back; otherwise, replace the blades regularly.

graphite transfer paper

This is a type of thin tracing paper with pencil or graphite rubbed into the surface. When a design needs to be copied or transferred to another surface, tape this paper to it with the black side down. Place your design over the transfer paper and copy using a hard pencil or a pen.

8 It is very difficult to write the same letters exactly the same length for each side of the box. Writing calligraphy on tracing paper on top of the alphabet layout is ideal for fitting the letters precisely within the length of the side of the box.

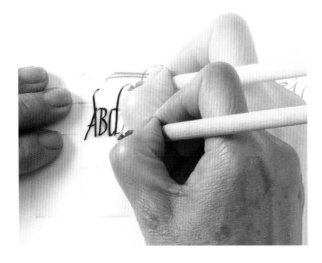

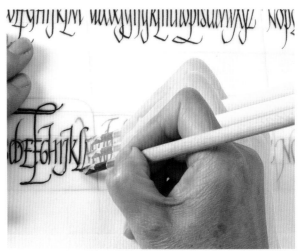

10 To fit this calligraphy written in capitals into the shorter side of the box, the alphabet is divided into two parts. Here, the pen is writing the first stroke of the letter "M." Even when writing smaller letters, move your hand rhythmically to maintain the pen angle and the evenness of your letterforms.

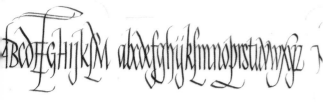

9 Make sure that the waterproof ink dries to a proper finish. Let the ink dry and add a little water to test its waterproofness.

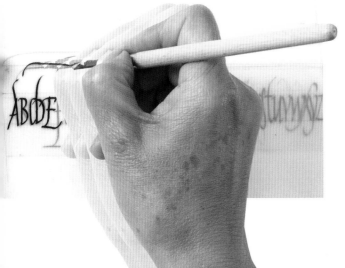

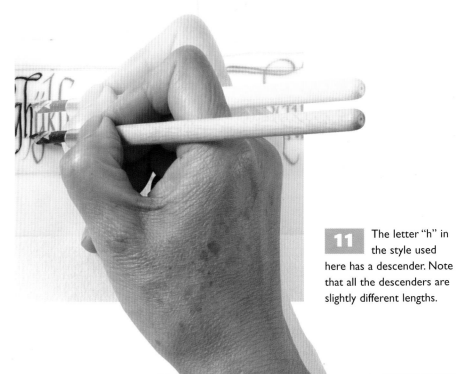

11 The letter "h" in the style used here has a descender. Note that all the descenders are slightly different lengths.

basic techniques

Writing with a calligraphy pen is unique. Unlike a ballpoint pen or pencil, which is a pointed writing tool, the calligraphy pen has a flat, wide, broad-edged writing tip.

writing pressure

Calligraphy is very different from ordinary writing; you need to position the writing edge of the pen very gently on the paper. When making the first strokes or marks using a calligraphy pen, take care to place light but even pressure over the entire width of the broad edge.

First, try holding the pen without any ink or paint in it. If you press too hard on the pen point, the slit will open and create a gap that does not allow the ink or paint to flow from the pen to the paper. Also, pressing too hard tires your fingers and wears out the pen point more quickly. If you press more

on one edge than on the other, the pen point will distort: for example, if you press on the left edge more than on the right edge, the left side will be pushed above the right side. With ink or paint, uneven pressure results in a rough, uneven edge on one side of the writing. As you write, try to be aware of the contact between pen and paper and how each reacts to the other.

holding the pen

Grasp the penholder in a comfortable but firm position, without gripping too tightly with your fingers. When writing, your fingers, hand, wrist, and arm all move. To capture the movement of the calligraphy pen on the page, try moving your whole arm back and forth in flourishes and round-abouts as well as up-and-down and side-to-side motions.

LEFT- AND RIGHT-HAND HOLDS

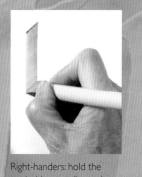

Left-handers: move your elbow toward your body, with your hand facing left. Slant the paper to maintain the angle of the pen.

Right-handers: hold the penholder at a diagonal angle, lightly and comfortably between your thumb and first finger.

WRITING WITH TWO COLORS IN AN AUTOMATIC PEN

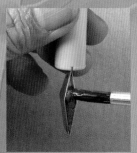

For an even flow, make a reservoir by cutting a sponge into the same shape as the inside of the broad-edged pen and pushing it into the center.

Use ink or mix paint so that it will flow through the pen. Apply the blue ink or paint using a brush or pipette to fill half of the sponge.

Rotate the pen to the other side. Apply the green ink or paint to the other half of the sponge. Saturate the sponge or else the color will not flow.

Make vertical strokes to test the flow of the dual colors. When adding color, apply the right color on the correct sponge edge.

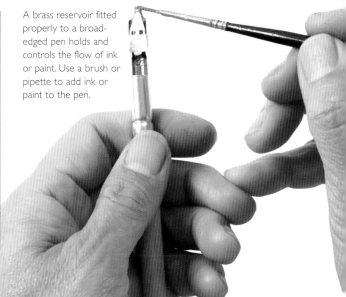

A brass reservoir fitted properly to a broad-edged pen holds and controls the flow of ink or paint. Use a brush or pipette to add ink or paint to the pen.

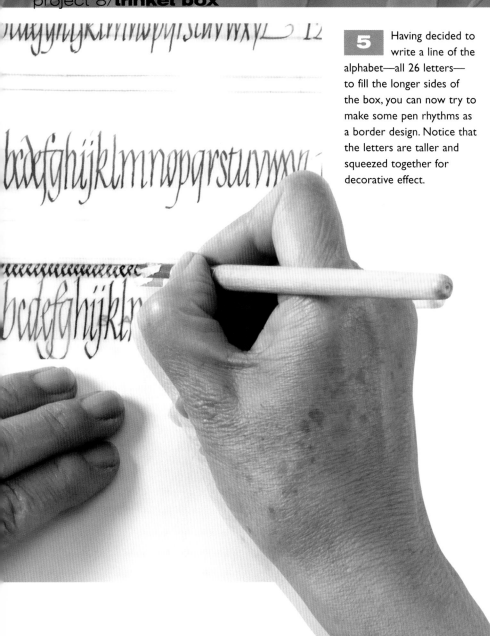

5 Having decided to write a line of the alphabet—all 26 letters—to fill the longer sides of the box, you can now try to make some pen rhythms as a border design. Notice that the letters are taller and squeezed together for decorative effect.

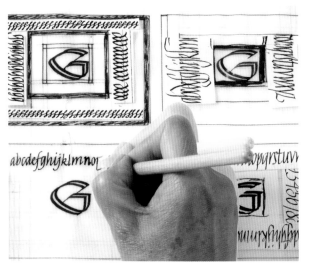

6 Experiment with some sketches when designing the lid of the box. Here, an alphabet border is being written. Other examples show a variety of decorative pen strokes.

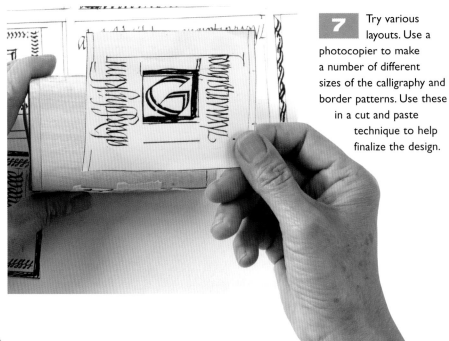

7 Try various layouts. Use a photocopier to make a number of different sizes of the calligraphy and border patterns. Use these in a cut and paste technique to help finalize the design.

basic strokes

The main reason the penholder is held diagonally in your hand is to allow you to maintain a comfortable pen angle for writing. For more than 1,000 years, most of the calligraphic alphabet styles have been written holding the pen this way, with the writing edge at an angle of between 30 and 45 degrees to a horizontal line.

The photographs below illustrate the practice and use of the calligraphy pen point at an angle of 45 degrees. Writing with a broad-edged pen produces wide, thick strokes and narrow, thin strokes. Holding the pen at this angle helps to achieve a harmonious balance between the thick and thin strokes.

the 45-degree pen angle

Holding the pen at a 45-degree angle allows the thick and thin lines to be distributed equally so that both the vertical and horizontal strokes are of the same thickness. The diagonals along the 45-degree line are thin lines.

By maintaining a consistent pen angle, a pattern of letter-forms is created; all the verticals are the same thickness, all the horizontals are the same thickness, and all the diagonals are positioned in the same place. This allows the letter shapes to be narrower and more easily written, saving both space and time.

Maintaining a consistent pen angle requires vigilance and regular self-checks. Check that all the verticals are the same thickness and that the angled beginning and ending triangular shapes are similar. Check that you are moving your elbow and putting the whole pen evenly down on the paper.

troubleshooting

- If the ink won't flow, there may be a coating on the point. Clean it off with hot soap and water or use a pen cleaner.
- If the paint is clogging the pen, the paint is too thick. Add water and mix the paint to a milky solution. Or the paint or ink may have dried inside the pen; clean it thoroughly.
- If the paper bleeds, the ink or paint is too thin or you need to change to another, better-quality, sheet of paper.
- If the pen is scratchy, write on very fine sandpaper (glasspaper) for a few strokes to take any rough edges off the pen.

VERTICAL STROKES

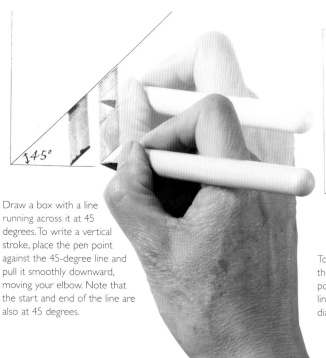

Draw a box with a line running across it at 45 degrees. To write a vertical stroke, place the pen point against the 45-degree line and pull it smoothly downward, moving your elbow. Note that the start and end of the line are also at 45 degrees.

DIAGONAL STROKES

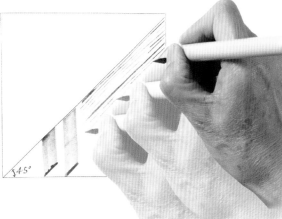

To write a diagonal stroke, place the writing edge of the pen point parallel to the 45-degree line. Move your hand and arm diagonally upward to the upper right-hand corner of the square. Make sure that the whole of the writing edge of the pen is touching the paper as you make the stroke.

HORIZONTAL STROKES

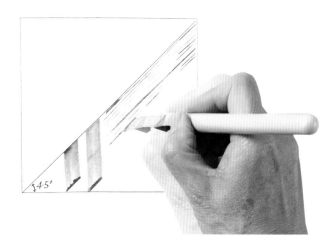

To create a horizontal stroke, position the writing edge of the pen parallel to 45-degree line. Move your elbow to the right while holding the pen at a constant 45-degree angle. The stroke should be the same thickness throughout and have the 45-degree beginning and ending.

1 Select an unpainted wooden box with a lid. To seal the surface of the box, paint with varnish, shellac, or diluted PVA glue, using a brush. Allow to dry thoroughly and sand the surface smoothly, using sandpaper (glasspaper).

3 Using a ruler and a felt-tip pen, carefully draw out the diagram of the box. This gives you a better understanding of its shape and construction. Note, for example, where the lid hinges are. Be sure to draw each panel of the box.

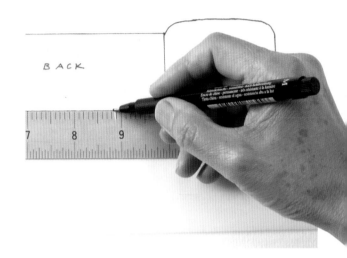

2 Lay the box on some regular-weight tracing paper. Trace each side carefully, including the top and bottom of the box, using a pencil. Rotate the box and consider how the calligraphy will cover it.

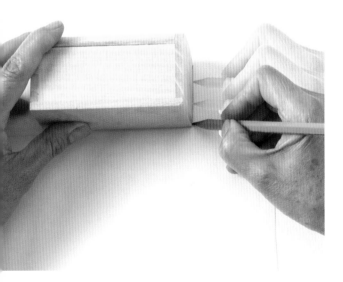

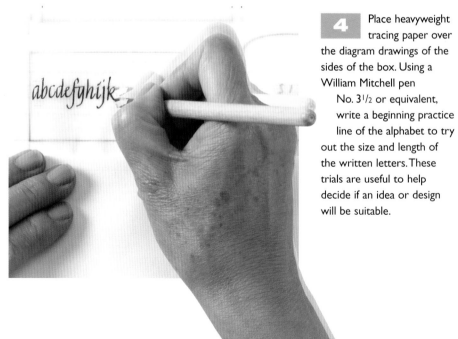

4 Place heavyweight tracing paper over the diagram drawings of the sides of the box. Using a William Mitchell pen No. 3^1/$_2$ or equivalent, write a beginning practice line of the alphabet to try out the size and length of the written letters. These trials are useful to help decide if an idea or design will be suitable.

BASIC LETTERS

Once you have the feeling of the pen and know how to write basic pen strokes, you can begin to combine the strokes to write letters. First, determine the height of the lowercase letters (minuscules). To do this, write five horizontal strokes, all stacked on top of each other (see right).

▶▶ To write the letter "i," hold the pen at a 45-degree angle and make a diagonal upward stroke. This creates a serif. Then, pull the pen downward to create a vertical stroke and finish the letter with another serif at the bottom.

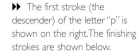

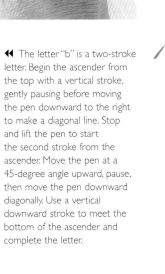

▶▶ The first stroke (the descender) of the letter "p" is shown on the right. The finishing strokes are shown below.

Begin with a diagonal stroke upward at 45 degrees. At the top, move the pen diagonally downward to the right to make a very short stroke. Then, bring the pen downward to make a vertical stroke, keeping the pen at a 45-degree angle throughout. At the bottom of the descender, stop and lift the pen.

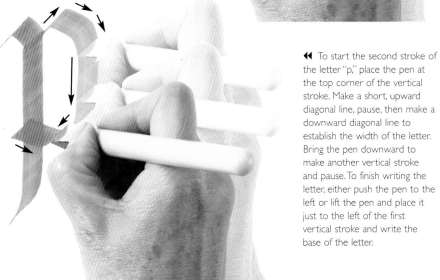

◀◀ The letter "b" is a two-stroke letter. Begin the ascender from the top with a vertical stroke, gently pausing before moving the pen downward to the right to make a diagonal line. Stop and lift the pen to start the second stroke from the ascender. Move the pen at a 45-degree angle upward, pause, then move the pen downward diagonally. Use a vertical downward stroke to meet the bottom of the ascender and complete the letter.

◀◀ To start the second stroke of the letter "p," place the pen at the top corner of the vertical stroke. Make a short, upward diagonal line, pause, then make a downward diagonal line to establish the width of the letter. Bring the pen downward to make another vertical stroke and pause. To finish writing the letter, either push the pen to the left or lift the pen and place it just to the left of the first vertical stroke and write the base of the letter.

project 8: **trinket box**

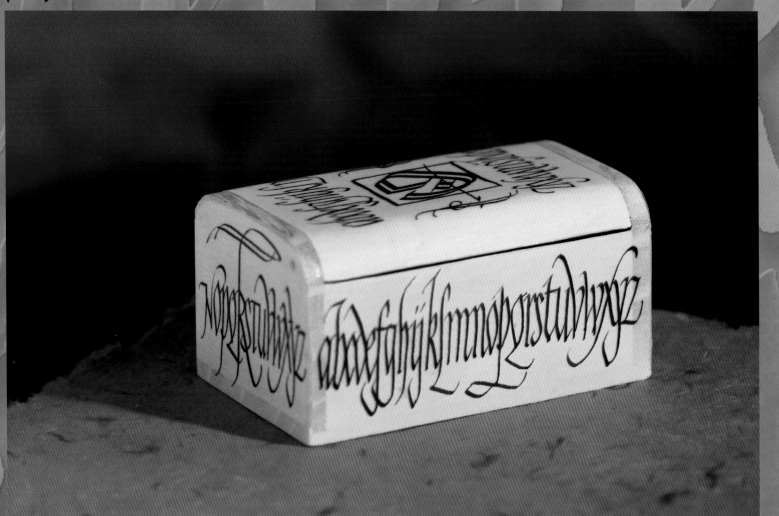

materials

Felt-tip pen

Heavyweight and regular-weight tracing paper

Paper towel or soft cloth

Pastel

Pencil

PVA glue or spraymount

Ruler

Sandpaper (glasspaper)

Scalpel, craft knife, or scissors

Simple, unpainted wooden box with a lid

Stiff brush

Variety of calligraphy pens: William Mitchell pens No. 3½ or 1mm or equivalent, No. 4 or 0.8mm or equivalent, and an Automatic pen No. 9 (¼in/6mm) or double-line equivalent

Varnish or shellac

Waterproof ink

▶▶ The style of calligraphy shown here is based on the diamond-shaped letter "o." Begin this two-stroke letter by moving the pen downward to the left toward the midway point of the letter height. Then, pull the pen back in toward the center of the letter at the base and finish with a thin, diagonal upward stroke. The second stroke begins again at the top with a thick, diagonal downward stroke to the right to about the midway point of the letter height. Then, pull the pen downward to meet the bottom of the letter.

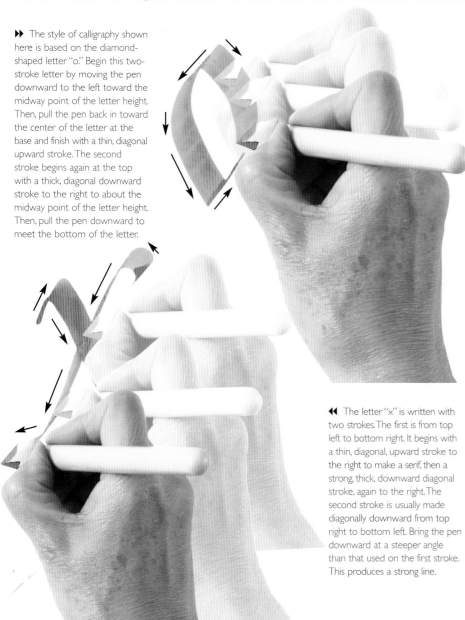

◀◀ The letter "x" is written with two strokes. The first is from top left to bottom right. It begins with a thin, diagonal, upward stroke to the right to make a serif, then a strong, thick, downward diagonal stroke, again to the right. The second stroke is usually made diagonally downward from top right to bottom left. Bring the pen downward at a steeper angle than that used on the first stroke. This produces a strong line.

WRITING A DECORATIVE CAPITAL

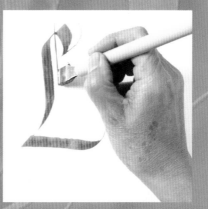

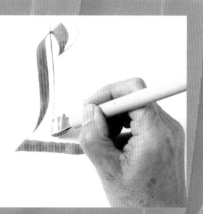

First, write the capital letter "L." To make the thin vertical line, rotate the pen so that it is vertical as shown, then pull it downward in a smooth stroke.

The vertical line has a slight curve at the bottom to mimic the vertical stroke of the capital letter. Move your arm to help you write the line more easily.

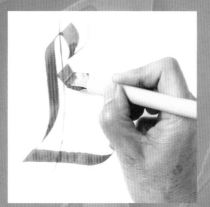

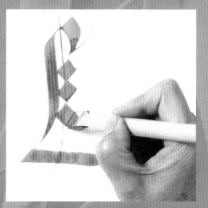

To make the diamond "dot," position the pen so that the left corner of the writing edge touches the vertical stroke of the "L." Pull the pen diagonally downward to the right.

For the next dot, slide the pen downward to the left at 45 degrees until the left edge of the pen point touches the "L." Repeat steps 3 and 4 to create a sequence of dots.

33 Once you are happy with your layout, paste the mounted photographs and the dried flowers into place on the background paper.

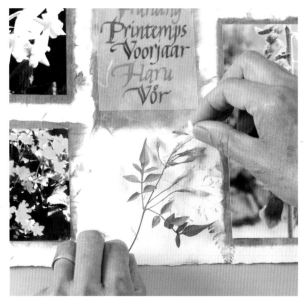

34 Cut out the botanical name labels, taking care to position the calligraphy centrally within the strip of vellum. Lay the labels on top of the flower photographs to help visualize their final position.

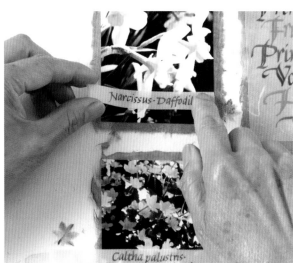

35 Because of the translucent quality of the vellum, use archival spraymount to stick the labels over the flower photographs. To coat the vellum strip in adhesive, place it upside down on a piece of scrap paper and cover it in an even layer of spray.

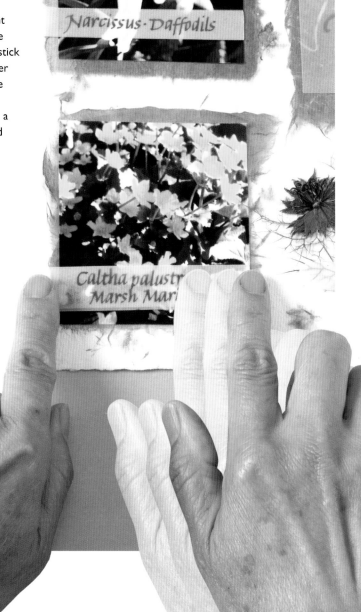

PUTTING LETTERS TOGETHER

Now that you have written basic strokes and individual letters, it is good practice to write related groups of letters: straight letters, such as "i," "l," "t," "f," and "j"; arched letters such as "r," "n," "h," "b," "p," "u," "y"; round letters such as "c," "e," "o," "d," "g," and "q"; and diagonal letters such as "v," "w," "x," "y," "z," and "k." Think about pen angle and moving your arm to develop a sense of rhythm as the pen forms the letter shapes.

Write words, then a phrase or sentence, and move on to a favorite poem. Notice how close together the letters are, which creates a visual pattern. When you write lines in calligraphy, think about the spaces between letters, words, lines, and margins. But the most important thing to do is enjoy yourself.

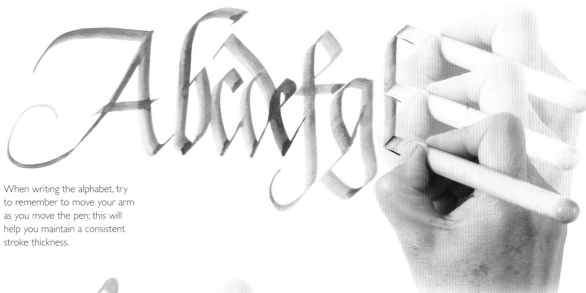

When writing the alphabet, try to remember to move your arm as you move the pen; this will help you maintain a consistent stroke thickness.

Notice that many letters are made up of similar shapes; for example, the first (left-side) stroke of the letter "o" is the same as that found on the letters "c," "d," "g" and "q." Likewise, the second (right-side) stroke is similar to that found on the letters "b" and "p." Also, the serifs and the letter sizes are similar from letter to letter. These distinct characteristics give uniformity and beauty to the calligraphy.

CLEANING YOUR PENS

Use clean water and a toothbrush to remove dried ink or paint on, or in, the pen point. Dry the point with a rag or paper towel.

To remove dried ink or paint inside the Automatic pen point, slip a piece of fine or stiff paper between the writing blades.

29 Once you have finished writing your botanical names, all the calligraphy is finished. Now make the paper mounts for the flower photographs and the "Spring" columns of words. Mix a watercolor or gouache wash in a palette and apply it to the rice paper with a wide brush.

31 Allow a few minutes for the water to absorb into the paper. Gently pull the sheet apart along the wet line. This will split the fibers and produce rough, uneven edges.

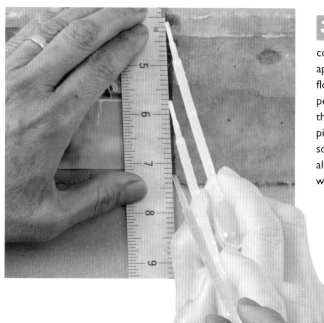

30 Let the paint dry. To "cut" the colored rice paper to the appropriate size for the flower photographs, use a pencil and ruler to mark the correct size. Fill a pipette with water and squeeze a trail of water along the ruler's edge where the line is drawn.

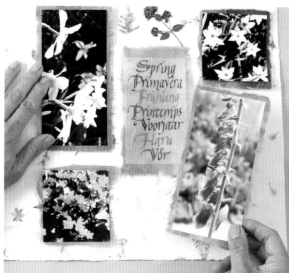

32 Using PVA glue, paste the photographs onto the colored paper background mounts. Arrange the various collected items into the columns marked earlier for a working layout. To make the dried flowers and leaves featured here, cut them off the plant and place them between paper towels. Press them under books until dry.

gallery

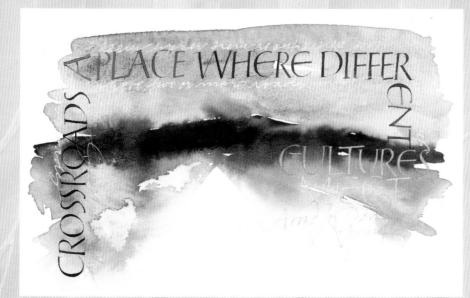

⬆ crossroads

nancy ruth leavitt

6½in x 9½in
(16.5cm x 24cm)

Gouache with brush and
William Mitchell pens. One in a
series of broadsides exploring
road imagery and color studies.

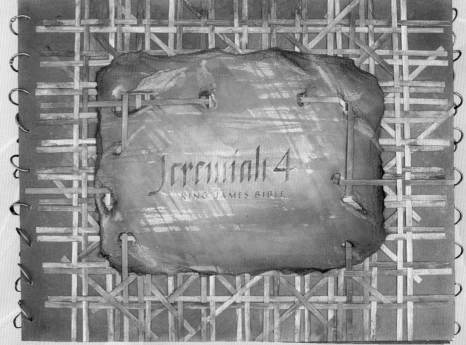

⟫ jeremiah 4, king james bible

elizabeth forrest

18¼in x 24⅛in
(45cm x 60.5cm)

The cover of a concertina book
of four pages made from
mounting board, joined by metal
rings. Woven painted paper
strips with watercolor paper
fragments. Pen-written letters.

25 Writing the letter "F"—even at a small size—requires a consistent pen angle and movement. Make the vertical stroke thicker than the thinner horizontal strokes for the crossbars.

27 Write the letter "x" in two separate downward strokes, the first from left to right, then vice versa.

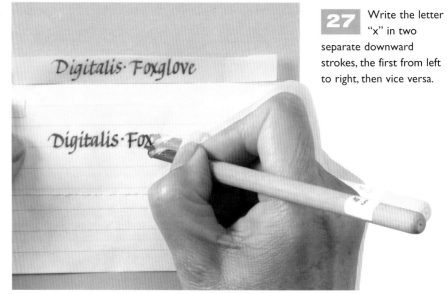

26 Allow the left horizontal flourish of the letter "F" to bridge the gap to the letter "s" of "Digitalis."

28 In the style of writing used here, the letters "a," "b," "c," "d," "e," "g," "o," "p," and "q" are not really rounded but have almost vertical sides to match the shape of the other letters. This condensed letter form helps to keep the line length short and the lettering compact.

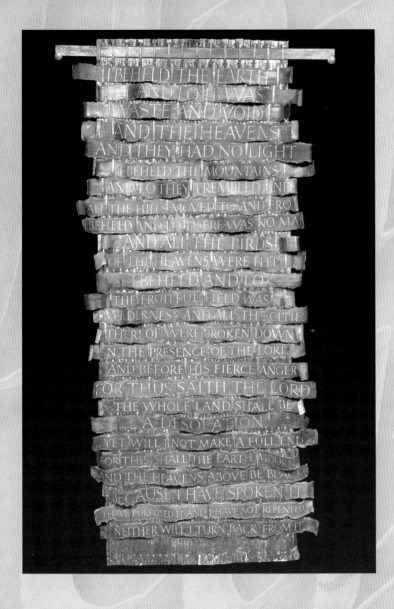

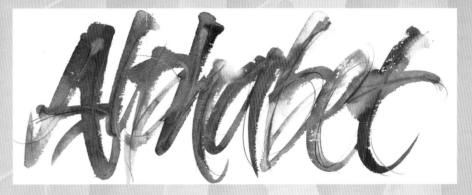

⬆ **alphabet**
rachel yallop
7in x 21in
(17.5cm x 52.5cm)

Colored inks and gold gouache
on heavyweight watercolor
paper using a large brush and
pointed steel nib.

◀◀ **jeremiah 4,**
king james bible
elizabeth forrest
49¼in x 26⅜in
(123cm x 66cm)

Wall hanging. Watercolor paper
strips woven through painted
packaging material. Painted
letters. Suspended from a
wooden baton.

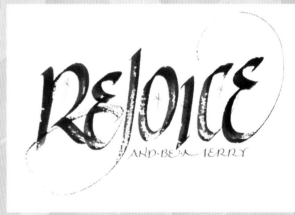

⬆ **rejoice**
margaret daubney
4¼in x 6¼in
(10.5cm x 15.5cm)

Christmas card using gouache
on watercolor paper with a
cold-pressed ("NOT") surface.

21 When writing ascenders such as the letter "l," try to keep all the vertical strokes—which appear on the letters "D," "f," and "d"—parallel. These vertical strokes are usually not completely upright, but slant very slightly forward.

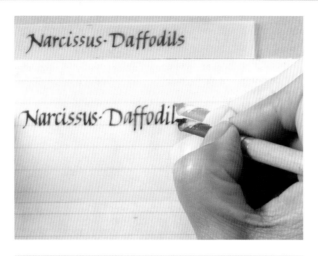

23 The letter "t" is short. The top of its crossbar touches the upper writing line. As before, the crossbar is a horizontal line thinner than the vertical stroke.

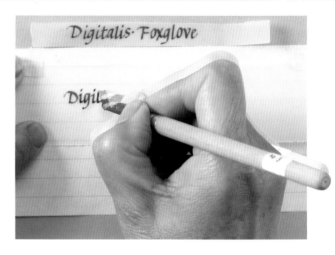

22 Ascenders and descenders are usually short in most calligraphic styles of writing, and capital letters are low in height. Consider following this style as the words you are writing here will be cut into horizontal strips to make labels; if your letters have long tails, the strips will be very wide.

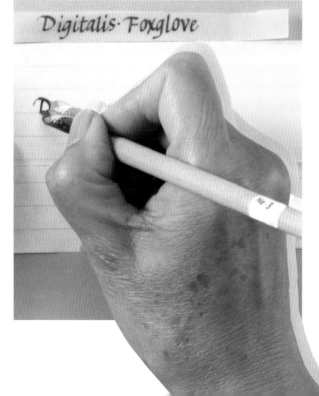

24 The letter "s" is usually written in two or three strokes starting from the top. The upper half is usually smaller than the lower half. Make sure that the letter does not slope to one side.

IS·IT·SO·SMALL
A·THING
TO·HAVE·ENJOYED
·THE·SUN·

TO·HAVE·LIVED·LIGHT
IN·THE·SPRING

TO·HAVE·LOVED
TO·HAVE·THOUGHT
TO·HAVE·DONE

MATTHEW ARNOLD

LINES FROM EMPEDOCLES ON ETNA

◀◀ **Matthew Arnold;
extract from
"Empedocles on
Etna"**
margaret daubney
**20³⁄₈in x 16³⁄₈in
(51cm x 41cm)**

Gouache and gold leaf
on Saunders Waterford
watercolor paper.

▶▶ **Shakespeare's
"Sonnet 99"**
maureen sullivan
**15¹⁄₂in x 8³⁄₈in
(39cm x 21cm)**

Ink and gouache on Fabriano 5
paper. Watercolor flower motif.

The forward violet
thus did I chide:
'Sweet thief,
whence didst thou steal thy sweet
that smells if not from
thy love's breath?

The purple pride
which on thy soft cheek
for complexion dwells in my love's veins
thou hast too grossly dyed.'

The lily I condemned for thy hand,
and buds of marjorum
had stoln thy hair;
The roses fearfully on thorns did stand
one blushing shame,
another white despair;
A third, nor red, nor white
had stoln of both,
and to his robbery had annexed thy breath;
but for his theft in pride
of all his growth
a vengeful canker eat him up
to death.

More flowers I noted, yet none I could see
But sweet or colour it had stoln from thee.'

W. SHAKESPEARE · SONNET 99

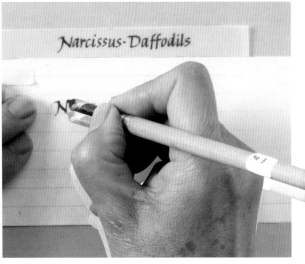

17 Next, write some botanical labels for the flower photographs using a William Mitchell pen No. 3½ or Speedball C.4 or equivalent. To avoid spelling mistakes, practice your writing on a sheet of tracing paper. Then, place the vellum over some lined paper and start to follow your practice writing.

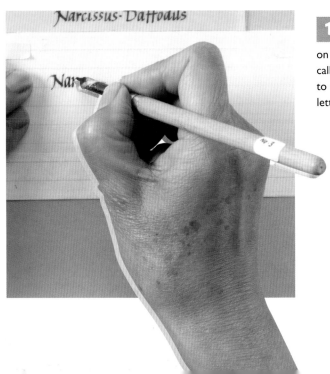

18 As you write the final version on the vellum, let your calligraphy flow. Do not try to copy the practice lettering exactly.

19 Keep the spaces between the letter "s" of "Narcissus," the dot, and the letter "D" of "Daffodils" very small so that the writing appears as one long line of letters.

20 Write the vertical stroke of the letter "D" first. The horizontal flourish on the letter can be made any size to bridge the gap between it and the letter "s" of "Narcissus."

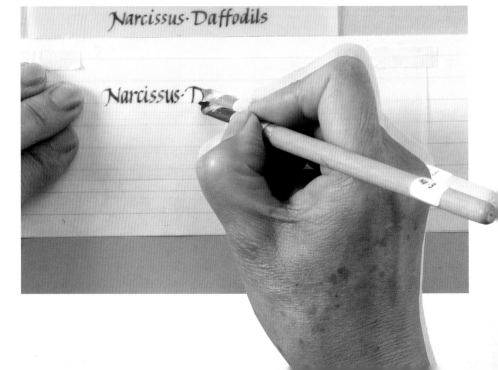

project 1: **place name and menu**

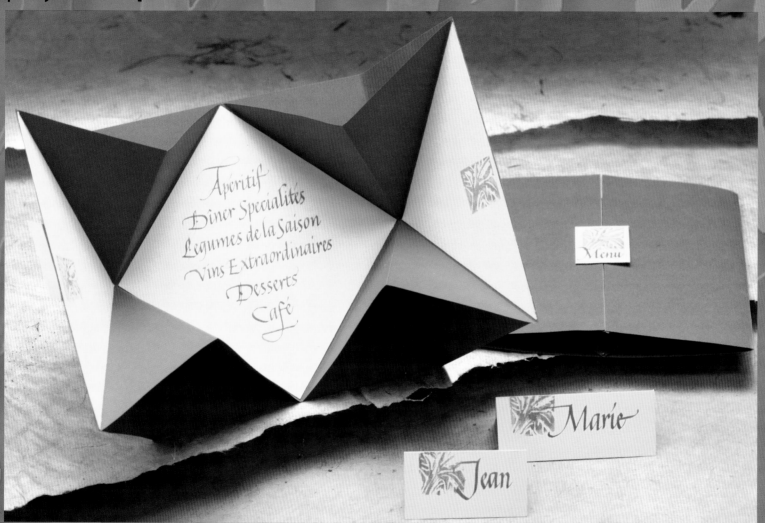

materials

- 2 vinyl or nylon erasers
- Black and red thin felt-tip pens
- Bone folder
- Cheap brush
- Craft knife or scalpel
- Double-sided tape
- Gold metallic powder
- Gouache
- Graphite transfer paper
- Gum arabic
- Heavyweight and medium-weight paper in two different colors
- Palette
- Pencil
- PVA glue or glue stick
- Ruler
- Scrap paper
- T-square
- Tracing paper
- Triangle (set square)
- V-shaped lino-cutter
- William Mitchell pens No. 3 or 1.1mm or equivalent, and No. 3½ or 1mm or equivalent

13 Use different watercolors, such as ultramarine blue and cerulean blue, for each of the multilingual words for "spring." Each color is manufactured using different minerals and ingredients; they therefore mix and flow through the pen slightly differently, and produce slightly different results.

15 Use double strokes with a flourish for the letter "H" of "Haru."

14 Rinse your pen point thoroughly in between each color.

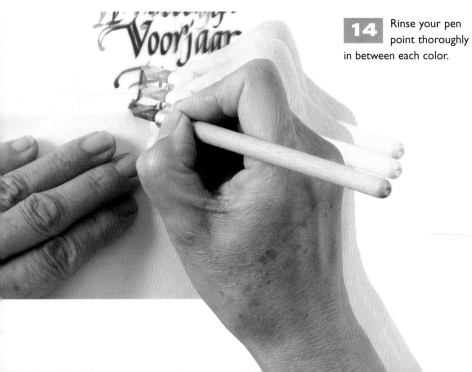

16 The crossbar of the letter "H" is a thinner line than the vertical strokes; flatten the pen angle slightly to achieve this.

1 To decorate your place name, first make a rubber stamp using a simple, basic design. The design shown here is leaves on a stem. For inspiration, look at ceramic tile designs, stencil patterns, or rubber stamp books. Draw a few ideas, using the black felt-tip pen, about 1in (2.5cm) square, onto some tracing paper, then select your favorite.

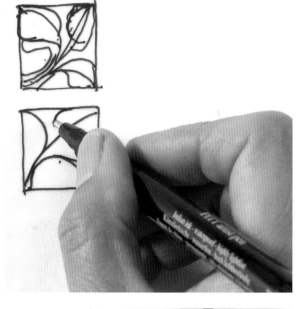

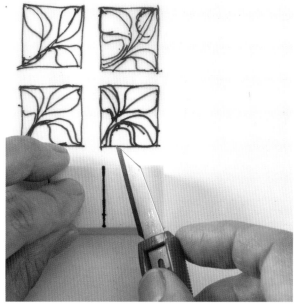

3 Using a sharp craft knife or scalpel, carefully cut the eraser along the line you have drawn. Always cut slowly, taking care to keep your fingers away from the blade. You will find that the eraser is as easy to slice as cheese.

4 Now, turn the tracing paper over. You need to do this because a print made from a rubber stamp is a "reversed" (mirror) image.

2 Next, select an eraser with which to make the rubber stamp. Use an eraser made of non-abrasive vinyl or nylon. Avoid kneaded or India rubber erasers, which are too soft to hold a design. Then, using a ruler, mark the dimensions of the design you have drawn on the tracing paper onto the eraser.

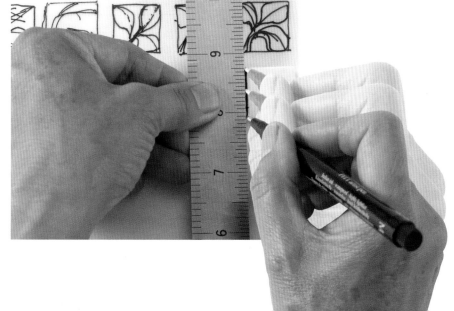

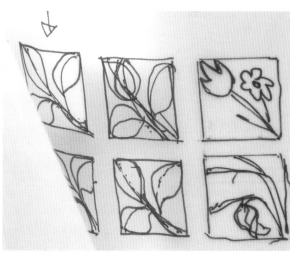

9 For the final version, place a sheet of vellum over the practice words and start to write, using cinnabar (olive green) watercolor paint. Do not try to copy each letter exactly as written before—allow your hand and pen to develop a relaxed, natural writing rhythm.

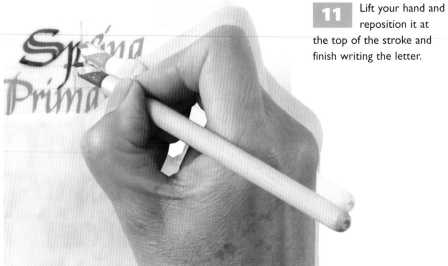

11 Lift your hand and reposition it at the top of the stroke and finish writing the letter.

10 When you write on smooth paper such as vellum, the pen moves across the page much more easily than on more absorbent layout paper. Maintain a steady writing pace and move your arm down to write the first stroke of the letter "p."

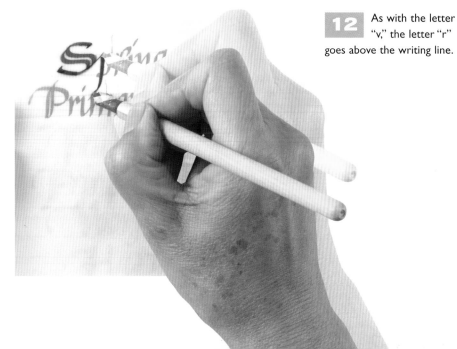

12 As with the letter "v," the letter "r" goes above the writing line.

5 Place the reversed tracing paper over the eraser; then slip a piece of graphite transfer paper in between the tracing paper and the eraser. Using the red felt-tip pen, trace over your design. Remove the tracing paper and graphite transfer paper. You will find that the design transferred onto the eraser is faint. To make it clearer, use the black felt-tip pen to go over the lines. Make sure you are happy with the pattern.

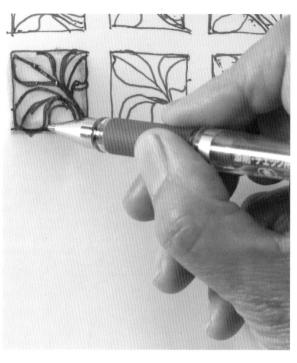

7 Try to cut grooves of different lengths and thicknesses into the eraser to add variety to your design. Then, mix a little green gouache and apply it to the eraser using a cheap brush. Make a trial imprint of the unfinished rubber stamp on a piece of scrap paper. This will show you how the cutting is progressing, what the design looks like, and which areas need more work.

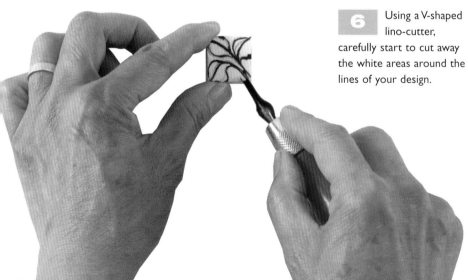

6 Using a V-shaped lino-cutter, carefully start to cut away the white areas around the lines of your design.

8 Using your lino-cutter, continue cutting and removing parts of the eraser's surface to finish your design.

5 Practice writing the double-line capital letter "P" for "Primavera," the Italian and Spanish word for "spring." Move the pen downward for both strokes. The finishing stroke is the flourish and round bowl of the letter.

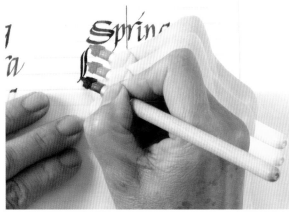

7 Some letters, such as the letter "v," may be flourished and go above the writing line.

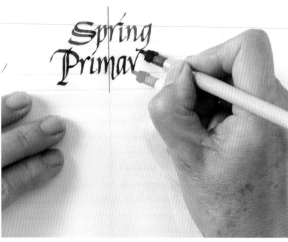

8 To write the letter "F" of "Frühling," move your whole hand to maintain a smooth writing rhythm. The first and second strokes are the vertical parallel lines. Flatten the pen angle slightly so that all the horizontal lines are thinner than the vertical ones.

6 Aim to achieve a rhythm and flow to your calligraphy, and think about how you are going to write the letters before you start them.

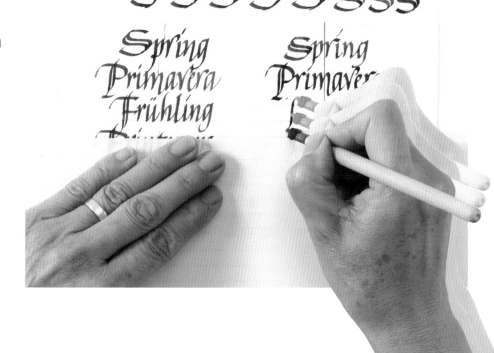

9 To enhance the green gouache, mix some gum arabic (about 10–15 drops) with half a teaspoon of gold metallic powder in a palette, to the consistency of custard. Squeeze the green gouache directly from the tube onto the palette, adding little or no water.

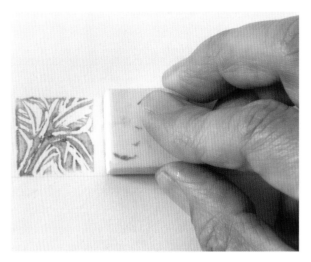

11 Draw a horizontal pencil line on a piece of scrap paper as a guide and then make some test prints with the stamp. Hold the stamp firmly and press down evenly to make sure that all the corners make contact with the paper.

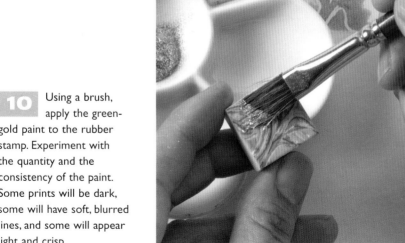

10 Using a brush, apply the green-gold paint to the rubber stamp. Experiment with the quantity and the consistency of the paint. Some prints will be dark, some will have soft, blurred lines, and some will appear light and crisp.

12 There is a wide choice of different colors and types of paper that are suitable for this project, such as the yellow heavyweight paper shown here. The easiest way to make place names is to draw long horizontal lines across the paper, about 3/4in (1.8cm) apart, to create guidelines for writing. Then cut the paper with a craft knife or scalpel into strips about 4in (10cm) wide.

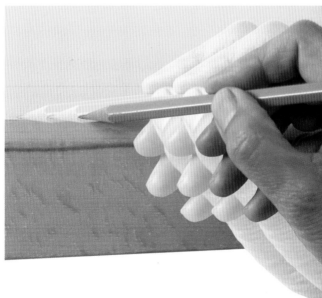

1 You can decorate your scrapbook with almost anything you like. Here, photographs of flowers taken from an old book, a variety of colored papers, vellum strips for labels, rice paper for the background mount, and dried flowers have been used to create an attractive spring theme.

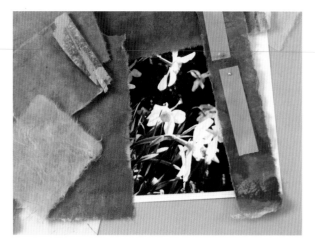

2 The cover for the scrapbook should be a piece of heavyweight paper. Using a T-square and triangle (set square), divide the page into three columns. This project evolves as the work progresses, shaping the scrapbook's appearance and character.

3 Place the tracing paper over the heavyweight paper and trace the width and depth of the column. Then lay the tracing paper over a photograph to select an area. Mark this area with a cut in each corner, then cut the photographs out with a craft knife or scalpel.

4 Next, practice writing your calligraphy with a William Mitchell pen No. 2$^{1}/_{2}$ or equivalent. The first word to practice is "Spring." Write the first letter, "S," in a double-line capital style. The first stroke is the upper stroke of the two lines. Make the second stroke parallel to the first.

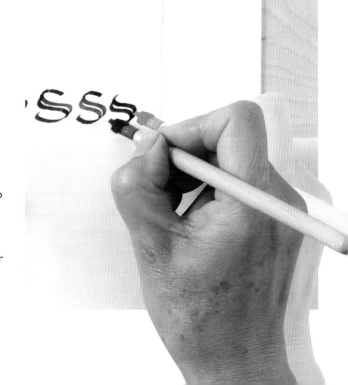

13 You are now ready to make a print with the rubber stamp and start writing some calligraphy. Apply the desired amount of paint to the rubber stamp and, beginning from the left edge of the strip of paper and using the bottom horizontal line as your guide, make a print.

14 The example name to write is "Marie." First, fill the pen with paint mixed with water to a milky consistency using a brush. Begin with the left vertical stroke of the letter "M." Note that the leading left flourish of the letter is over the rubber stamp print. Hold the pen gently as you write and try to develop a rhythm. Use some pressure on the down strokes and light pressure on the upstrokes to create different line weights.

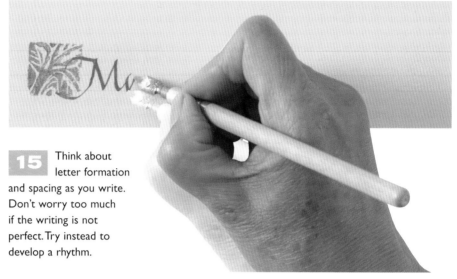

15 Think about letter formation and spacing as you write. Don't worry too much if the writing is not perfect. Try instead to develop a rhythm.

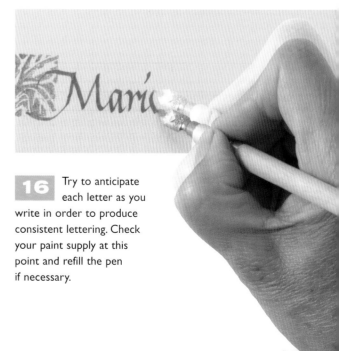

16 Try to anticipate each letter as you write in order to produce consistent lettering. Check your paint supply at this point and refill the pen if necessary.

project 7: **scrapbook cover**

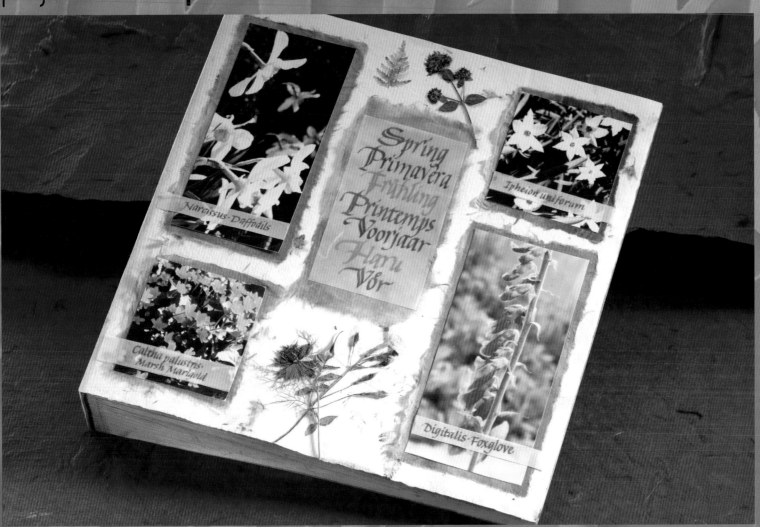

materials

- Archival spraymount
- Cinnabar, ultramarine blue, and cerulean blue watercolor paints
- Craft knife or scalpel
- Cutting mat
- Flowers
- Gouache paints
- Heavyweight paper in a variety of colors
- Palette
- Paper towels
- Pencil
- Photographs printed onto paper
- Pipette
- PVA glue
- Rice paper
- Ruler
- Scrapbook
- T-square
- Tracing paper
- Triangle (set square)
- Vellum
- Wide brush
- William Mitchell pens No. 2½ or 1.8mm or equivalent, and No. 3½ or 1mm or equivalent or Speedball C.4

17 Finish writing the letter "e," then pause and readjust the position of your hand and arm to pull the pen horizontally across the paper for the flourish. Finish the flourish with a thin, upstroke finale. This completes one place name.

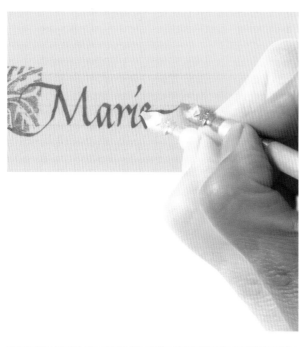

18 Start the next place name on the same long strip of paper, allowing plenty of space for cutting between one place name card and another. Add more paint to the rubber stamp and make another print as before.

19 Check that the paint in the pen is still wet by writing on a piece of scrap paper. If the paint has dried up, wash out the pen, dry it, then refill.

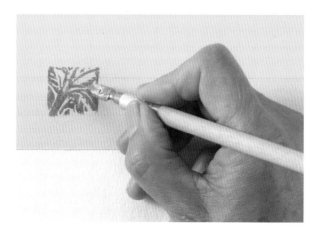

20 Starting with the pen inside the print, practice the movement of writing the next name, "Jean," starting with a flourished capital "J." Move your arm freely for the horizontal stroke.

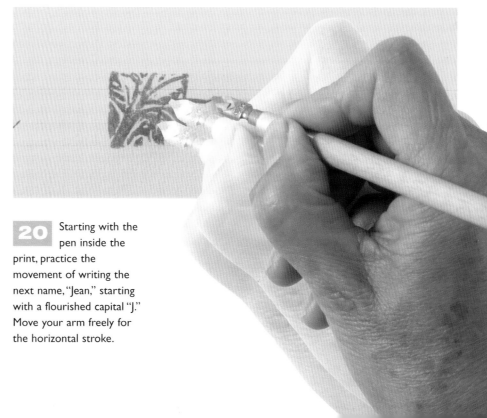

32 To complete the fold, place the fingers of both hands on the crease as shown and gradually move them to the bottom edge. Return your fingers to the center and move them up to the top edge.

33 Heavyweight papers can be difficult to fold neatly. If this is the case, place a clean piece of scrap paper on the fold and press firmly down using the rounded end of a bone folder.

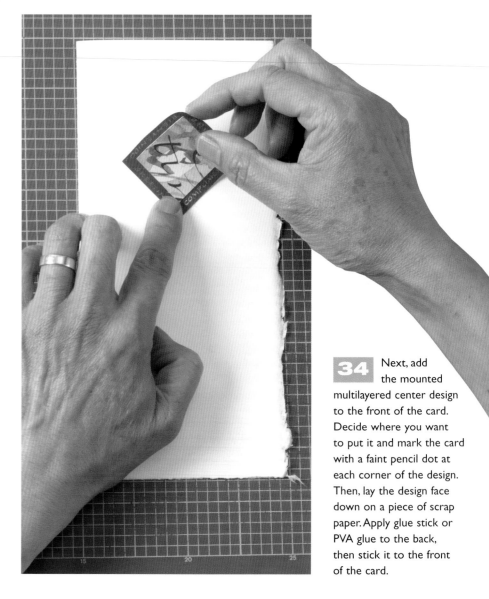

34 Next, add the mounted multilayered center design to the front of the card. Decide where you want to put it and mark the card with a faint pencil dot at each corner of the design. Then, lay the design face down on a piece of scrap paper. Apply glue stick or PVA glue to the back, then stick it to the front of the card.

21 Write the horizontal line of the capital "J" first, continue down the vertical stroke, then finish with the upstroke. Take the pen off the paper before starting the next letter. Again, try to develop a rhythm as you write.

22 In calligraphy, the letter "e" is written in two strokes. Each stroke begins at the top and the pen is pulled downward.

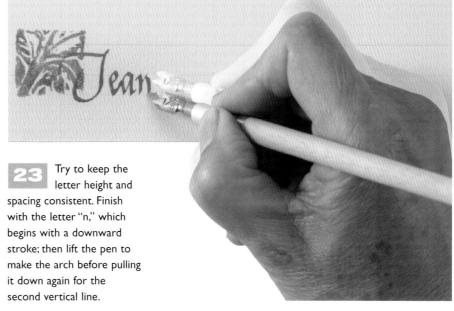

23 Try to keep the letter height and spacing consistent. Finish with the letter "n," which begins with a downward stroke; then lift the pen to make the arch before pulling it down again for the second vertical line.

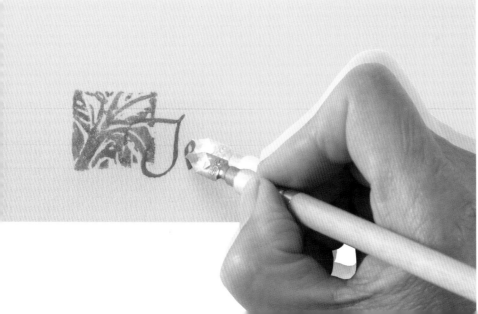

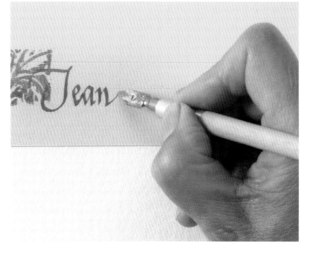

24 To finish the letter, create a serif. Use a very light diagonal stroke and pen lift to do this.

29 Next, make a crease in the card. Because the paper is thick, it is best to score a line to make a neat fold in the paper. To do this, use a ruler to mark the line and firmly pull the pointed end of a bone folder along the edge of the ruler. Score the card twice.

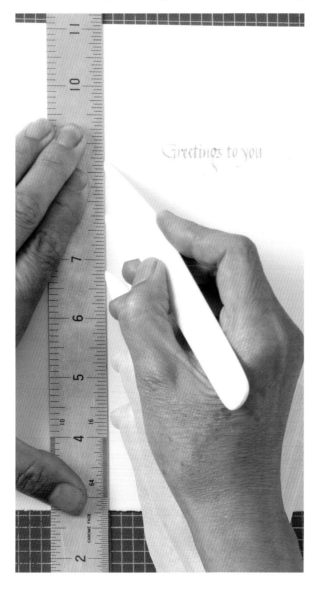

30 Start to fold the card over. Keep your left hand near the center fold line to hold the paper in position as you bring the other side over.

31 Fold the paper all the way over, aligning the deckle edges. Keep the thumb of your right hand on the bottom edge of the card to make sure all the edges are flush. You can also use the grid on the cutting mat to guide you.

25 Having completed all your prints and names, let the paint dry thoroughly. Decide whether to make the cards the same length or vary them slightly according to the differing lengths of the names. Using a triangle (set square), draw a pencil line where the vertical cut will be.

26 Using a triangle (set square), cut the card along the line you have just drawn with a scalpel or craft knife. Always cut toward yourself, keeping your fingers and hand away from the knife blade. Using a soft vinyl eraser, gently rub out all pencil lines.

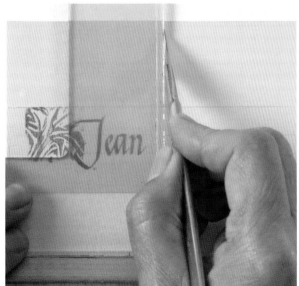

27 To help fold the card neatly in half so that it will stand up, score a light line along the fold line with the back of a scalpel blade or craft knife, guided by a T-square or ruler. Take care not to cut through the paper.

28 After scoring the line, fold the paper over. Place a clean sheet of scrap paper over the fold, and using a bone folder, make a clean, neat crease. Stand the finished place name card upright on the table.

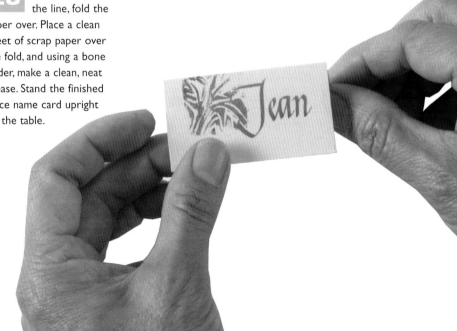

25 Place your strip of practice calligraphy above the tram lines. Fill your pen with a light watercolor wash, in this case a purple one, make sure the pen works by writing on a piece of scrap paper, then start to copy the letters from the practice calligraphy strip directly onto the card.

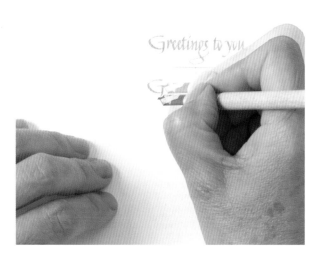

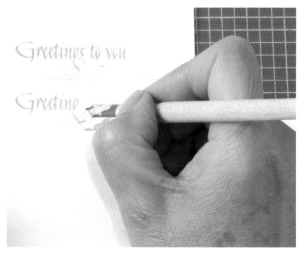

27 Join the tail of the letter "g" to the letter "s" so that all the letters are joined.

28 Try to maintain a relaxed rhythm as you write, all the way to the end of the line.

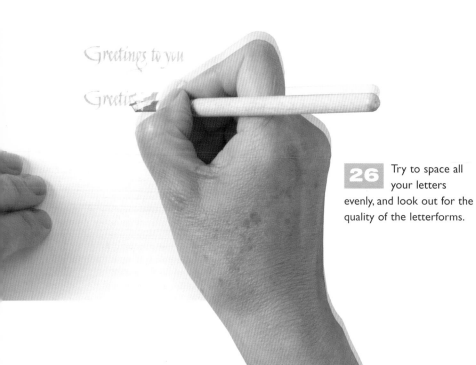

26 Try to space all your letters evenly, and look out for the quality of the letterforms.

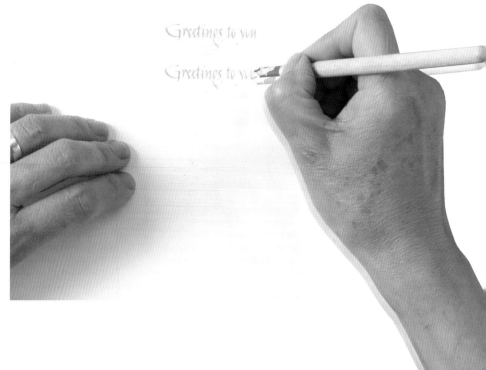

1 There are three parts to this project: an outer menu holder, an inner folded sheet, and a menu card. First, make the outer menu holder. Take a piece of medium-weight card twice as wide as it is long. In the example on the right, the paper is 6in (15cm) x 3in (7.5cm). Mark the center line with the right-hand edge of a ruler. Fold the right-hand edge of the card toward this center line.

3 To make a really crisp crease, apply the rounded end of a bone folder. To prevent the bone folder "smoothing and polishing" the surface of the paper, place a piece of scrap paper between the bone folder and the card. This extra leaf of paper will prevent the bone folder polishing the paper. Remove the ruler and repeat the fold on the left side of the card. This completes the outer menu holder.

2 Using your fingers, create a crease by pressing lightly from the center of the fold to the bottom edge. Then return to the middle of the fold, and press lightly from the center toward the top.

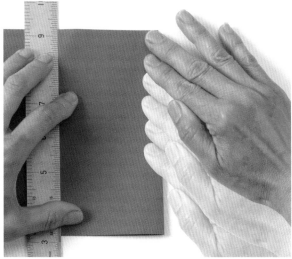

4 The second task is to make the inner folded sheet, which will be attached to the outer menu holder. Cut a second piece of card about $1/8$in (3mm) smaller in both dimensions than the first piece. Lightly mark a vertical center line with a pencil. Take the bottom right corner of the paper and fold it diagonally up to the center line.

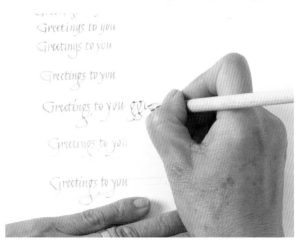

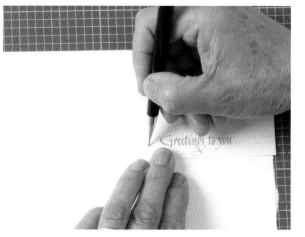

21 For the message inside the card, first practice writing your greeting in a variety of styles on a piece of scrap paper. Here the words "Greetings to you" have been written, some with long descenders and some with short ones. This is a good way of practicing different strokes and styles.

23 Once you have found the ideal position for the calligraphy strip, lightly mark the card with a very faint pencil line. Mark the top, the center, and the bottom of the writing line. The top line is also known as the "waist line."

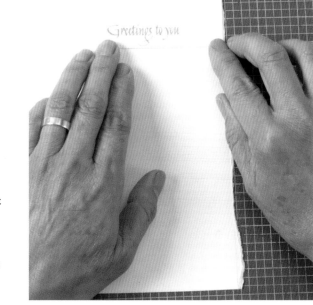

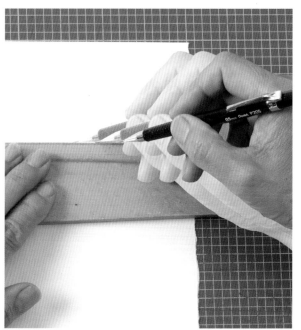

22 Choose the calligraphy style you like best and cut it out as a small strip of paper. Move the strip around the inside of the card to find out which position is most attractive—centered, high up, low down, and so on.

24 Now move the T-square up to the top and bottom marks and extend them into two parallel lines (tram lines) for the letter height.

5 Take care that the corner touches the top of the center line and that the two edges of the card meet at the top. Use your fingers to make a crease, from the center of the fold to the bottom corner, then from the center to the top corner.

6 Open the folded card. The next fold will be made in the opposite direction.

7 Take the upper right-hand corner and fold it downward to the center line. Use your fingers to make a firm crease. You should now have two crisscross diagonal folds.

8 Turn the sheet over. Mark the center line on this side of the sheet as before. Then fold the side with the creased diagonals on in half by taking the right-hand edge of the sheet to the center line. Turn the paper back onto its original side and repeat steps 4–8 on the left-hand side.

17 Carefully position the multilayered design in the center of the colored paper. Work on a cutting mat—the graph lines will help you align your work accurately.

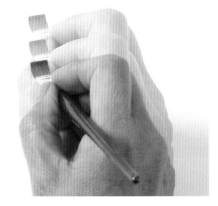

19 With a pencil, put a small arrow on the paper to indicate the direction of the grain, and mark out the card to your desired size and shape. Then, apply a brush load of clean water along the pencil line that marks the edge of the card. Wait a few minutes for the water to soak into the paper.

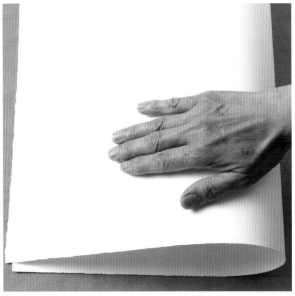

18 To make the greeting card itself, select a sheet of heavyweight paper, or 90lb (190gsm) watercolor paper. Your card will stand up best if the fold you make runs parallel to the grain of the paper. Roll the paper to see which way the grain lies. Rolling against the grain will give most resistance.

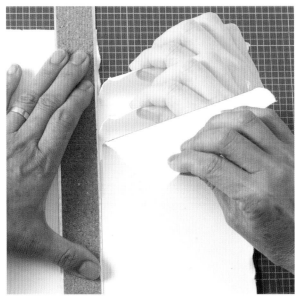

20 Holding a ruler along the right-hand pencil mark, start to tear, rather than cut, the card. Holding the ruler firmly in place, move the paper slightly to the right and make a tear, then move it slightly to the left and make another tear, and so on, to create a ragged or deckle edge. Repeat the wetting and tearing process on the left-hand pencil mark.

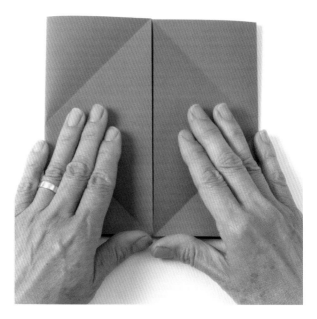

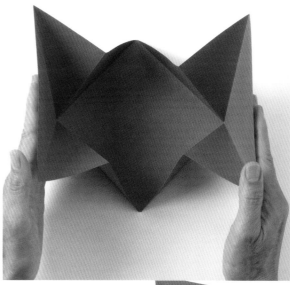

9 The folded sheet should look like the picture shown on the left, paper edges folded to the center line with another square formed by the creases positioned diagonally in the middle.

11 Turn the folded sheet over. With your fingers, gently crease the folds again and collapse the paper to a square, which will be positioned diagonally in front of you.

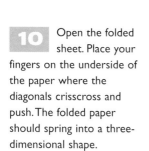

10 Open the folded sheet. Place your fingers on the underside of the paper where the diagonals crisscross and push. The folded paper should spring into a three-dimensional shape.

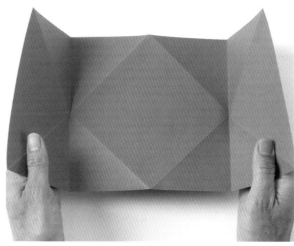

12 Open the inner folded sheet once more. Measure one side of the center diamond with a ruler. This should be 4¼in (10.6cm). Make a note of this. The menu card, on which you will write your calligraphy, will be attached to this diamond shape. The menu card needs to be a little smaller than the inner folded sheet, at 4³⁄₁₆in (10.5cm) on each side.

13 Paste the multi-layered square of calligraphy onto the middle of one of the colored squares with a thin layer of PVA glue or glue stick. Using a cutting mat, check that it is correctly aligned.

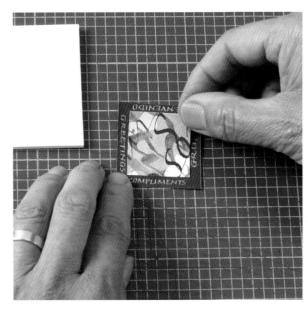

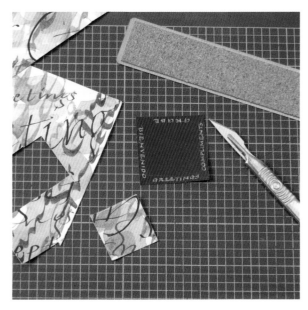

15 To make the greeting card, gather the materials you will need. These are a square of multilayered calligraphy paper, the second colored background square, a ruler, a scalpel or craft knife, and white heavyweight paper.

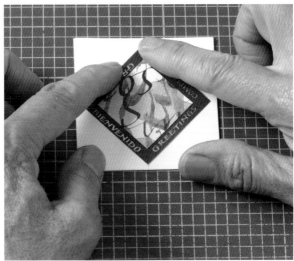

14 To make a gift tag, fold a piece of white heavyweight paper in half. The front cover should be just larger than the multilayered colored motif. Position the motif with two opposite points on the center line.

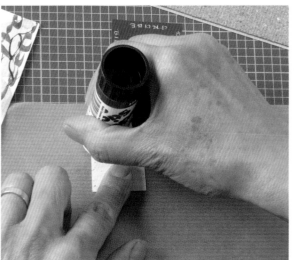

16 Turn the multi-layered calligraphy square face down on a piece of scrap paper. Using a glue stick or PVA glue, add a thin, even layer of paste to the square, making sure that the edges of the paper are well covered.

13 Collapse the inner folded sheet again into a square and turn it over onto its front (the side on which there is no opening is now facing upward). Paste a thin layer of glue stick (or PVA glue) onto the card.

15 Next, apply some glue stick or PVA glue to the center edge of the right triangle of the diamond. To do this, slip a piece of scrap paper into the right-hand diamond pocket. This stops the left-hand edge of the diamond from being covered in glue.

14 Open the outer menu holder you made in steps 1–3. Position the inner folded sheet along the center line of the holder. Make sure that the top and bottom points of the diamond are aligned with the center line already marked on the outer menu holder. Press down firmly.

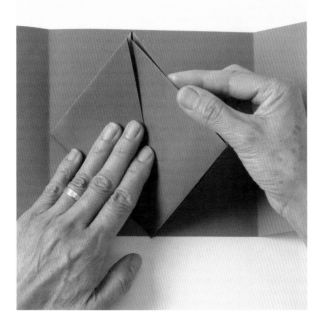

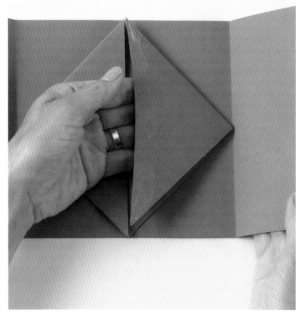

16 Slip your left hand into the right-hand diamond pocket and press it onto the right-hand side of the outer menu holder. Check to make sure that the position of the center edge of the diamond is aligned with the edge of the outer menu holder.

9 Keep writing new words until the whole page is covered in calligraphy. Allow the paint to dry. This completes the wrapping paper.

10 To make the gift tag, isolate a small 1in (2.5cm) square section of writing near the edge of the wrapping paper. To locate a suitable area, move a black cropping L over the surface of the paper. When you have found an area you like, mark it with a pencil and carefully cut it out with a scalpel or craft knife. Take care to keep your fingers away from the blade. Trim the page so that the wrapping paper has a smooth edge.

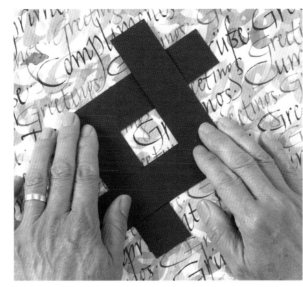

11 Then take a piece of the blue heavyweight paper and lightly draw some writing guidelines in the shape of a square with a pencil. Make two of these. These squares should be big enough to allow the piece of calligraphy you have just cut out from the wrapping paper to fit in the middle.

12 With some gold pearl gouache, write the word "Greetings" in several languages around the two squares. Stir the gold pearl gouache frequently, using a brush as the gold settles in the palette. Let the paint dry and cut the cards out.

17 Repeat the pasting process on the left side, then close the outer menu holder. This completes the joining of the outer menu holder and the inner folded sheet.

19 Next, draw a vertical line 4³⁄₁₆in (10.5cm) long using a triangle (set square). Then move the triangle (set square) along the horizontal line by 4³⁄₁₆in (10.5cm) and mark another vertical line to the same height. Continuing in this way, mark out a least two squares. Using a craft knife or scalpel, carefully cut out the squares, making sure to keep your fingers away from the blade.

18 Next, make the menu card. Take some colored paper (yellow has been used here) and some green gouache (to match the color of the outer menu holder) for writing the calligraphy. Use a T-square and triangle (set square) to mark out the dimensions of the menu card; start by drawing a long horizontal line across the paper with the T-square.

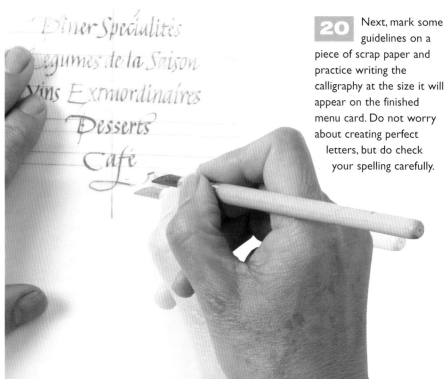

20 Next, mark some guidelines on a piece of scrap paper and practice writing the calligraphy at the size it will appear on the finished menu card. Do not worry about creating perfect letters, but do check your spelling carefully.

5 The overall image is beginning to form. The first layer is light, thick-lettered calligraphy. The second layer is slightly darker, still using large letters, and this third layer is the darkest, written with the small pen.

7 Note how the tail of the letter "p" joins with the curve of the letter "S" to join the two separate lines of writing neatly together.

6 To write the first stroke of the capital letter "S," begin at the top and move the pen down in one stroke, beginning with a curve, then moving onto a straight line for the middle of the letter and finishing with another curve.

8 Try not to grip the pen too tightly as you write. Also, keep the pen point clean as you proceed by wiping it with a soft, damp piece of scrap cloth.

21 Turn your practice sheet upside down and turn it over. Fold the bottom line of the sheet back to reveal the top line of your practice writing. Position it above the first line of the menu card and copy the writing. This method is very useful for accurately writing and centering a line of calligraphy. Fill the pen, check the flow of paint, and start writing.

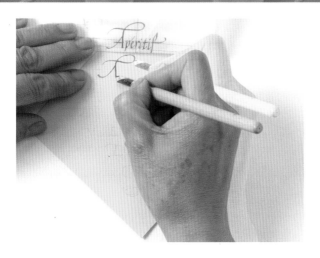

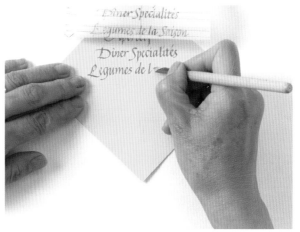

23 Look for relationships between the shapes of the letters—the letters "a" and "g," and "d," "b," and "p" all have similar shapes. If you need to refill your pen, take care not to add too much paint as this will result in darker letters than those you have written previously.

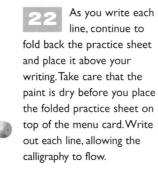

22 As you write each line, continue to fold back the practice sheet and place it above your writing. Take care that the paint is dry before you place the folded practice sheet on top of the menu card. Write out each line, allowing the calligraphy to flow.

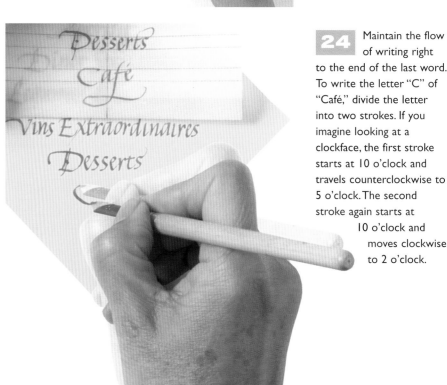

24 Maintain the flow of writing right to the end of the last word. To write the letter "C" of "Café," divide the letter into two strokes. If you imagine looking at a clockface, the first stroke starts at 10 o'clock and travels counterclockwise to 5 o'clock. The second stroke again starts at 10 o'clock and moves clockwise to 2 o'clock.

1 Using a very light blue watercolor wash and white lightweight paper, write the word "Greetings" repeatedly across the page with a large pen, 1in (2.5cm) or equivalent. Note that each line of writing touches the line above it, packing the letters together to form a massed texture. Allow the wash to dry.

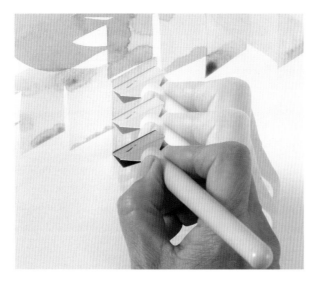

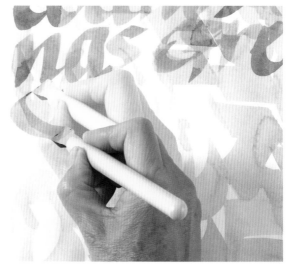

3 The whole mass of writing is composed of only one repeated word. When you reach a line end, break the word wherever necessary and continue where you left off on the next line. Allow the wash to dry.

2 Rotate the paper 90 degrees. Write "Greetings" again using a 1/2in (12.5mm) pen or equivalent, using a slightly darker blue watercolor wash. You can write in any calligraphic hand you wish and allow the letters to touch each other.

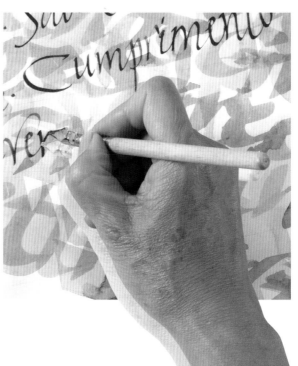

4 Using a medium-sized pen, such as a Speedball C.3, a 2mm pen or equivalent, write the word "Greetings" in several different languages on the diagonal in an even darker blue watercolor wash. If you need to, draw some light pencil lines to help keep your calligraphy straight.

25 To write the letter "f," start at the top, but then rather than pushing your pen to the left, where the dry paper would resist the pen point, first make the stroke to the right. This creates a wet patch of paint on which the pen can slide easily when pushed back to the left. This technique can also be used on all lettering strokes moving left.

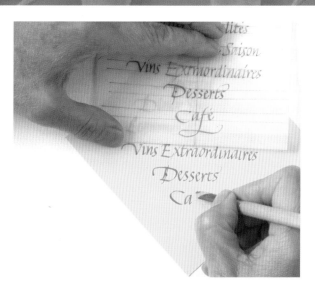

26 The completed yellow menu card is now ready to be fixed onto the green inner folded sheet. Lay the menu card face down on a piece of scrap paper. Apply a thin layer of PVA glue or glue stick around its edges and carefully position it in the middle of the inner folded sheet. For further decoration, take a yellow square and cut it in half to make two triangles. Add the rubber stamp print made in the previous Place Name project.

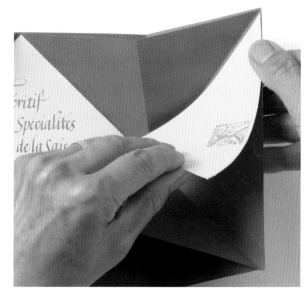

27 Using some PVA glue or glue stick, paste the triangle to the inner folded sheet in the triangular space on the right. Make sure that the edges align. Repeat on the left-hand side.

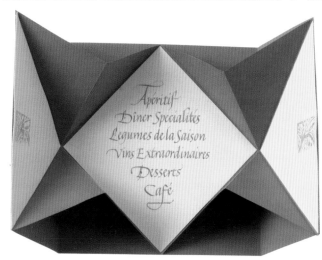

28 To keep the menu closed, mark a small rectangle on a sheet of your yellow paper. Stamp a print on it and write the word "Menu" underneath. Cut out the rectangle and stick it to the outer menu holder using a piece of double-sided tape. The menu can then be opened and closed.

project 6: **wrapping paper, gift tag, and greeting card**

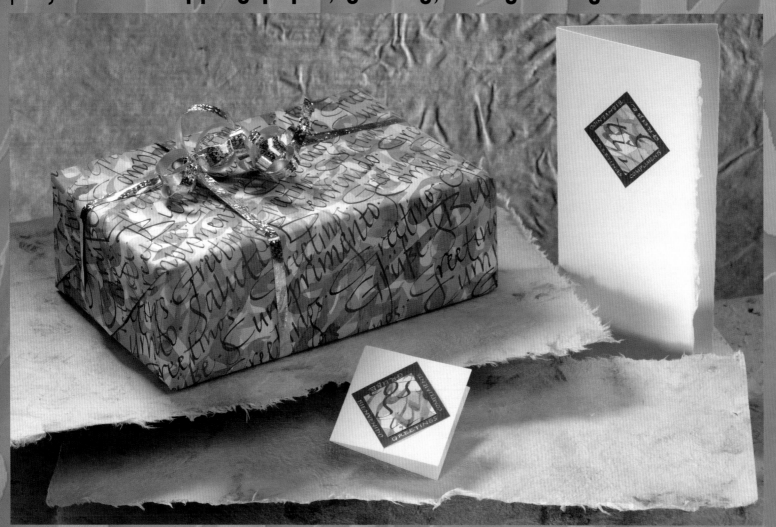

materials

Blue and purple watercolor paints

Bone folder

Brush

Cropping L

Cutting mat

Gold pearl gouache

Pencil

PVA glue or glue stick

Ruler

Scalpel or craft knife

Scrap cloth

Scrap paper

T-square

Variety of calligraphy pens: 1in (2.5cm) pen or equivalent, Speedball C.3 or 2mm or equivalent, ½in (12.5mm) pen or equivalent

White lightweight and blue and white heavyweight papers

project 2: **invitation**

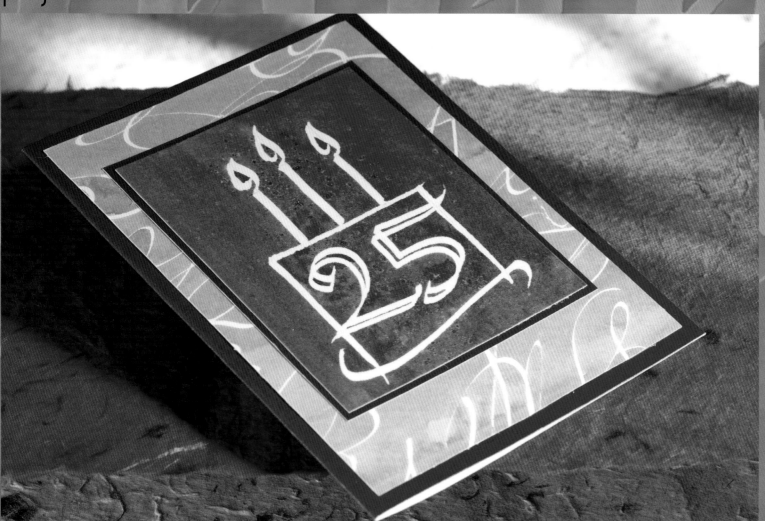

materials

2 different shades of blue watercolor paint

Automatic pens No. 2 (⅛ in/3mm) or equivalent, and No. 9 (¼ in/6mm) or two-line equivalent

Blue and white watercolor papers, 140lb or 300gsm

Craft knife or scalpel

Masking fluid

Pencil

Pick-up rubber square or masking tape

PVA glue or glue stick

Ruler

Scrap paper

T-square

Triangle (set square)

Wide, soft-hair brush

William Mitchell pen No. 1½ or 2.5mm or equivalent

23 When you have confidence in printing the leaves, make prints on the piece with calligraphic lettering. Press the leaf lightly with a clean paper towel and lift it carefully to avoid smearing the wet paint.

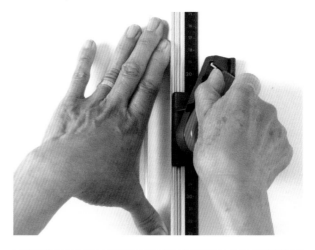

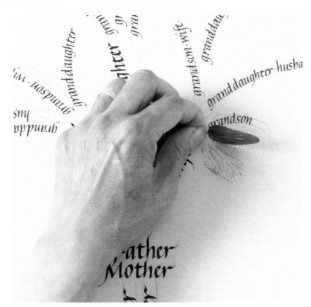

24 Scatter the leaves to fill in the gaps between the writing and to create the pleasing shape of a healthy tree. Use medium-sized and small leaves, taking care to vary the angles of the leaves—most leaves point outward from the center of the tree. When the leaf prints are complete, let the paint dry thoroughly. Now, the piece of calligraphy needs to have a mat (mount) cut.

25 Lay a sheet of tracing or layout paper on top of the finished piece and hold it in place with masking tape. Use a T-square and triangle (set square) to mark the margins between the family tree and the mat (mount). Transfer the measurements on the back of the mat board.

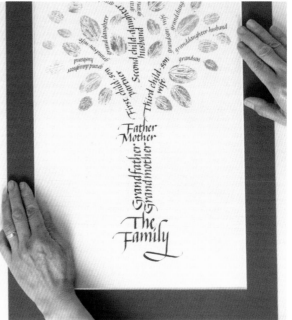

26 Place the cut mat (mount) on top of the "Family Tree." Adjust until you are happy with its position. Cut the paper if necessary. Use archival tape to hold the paper in place on the mat (mount).

1 This project is an invitation to a 25th birthday or anniversary celebration. First, come up with some ideas for your design by doodling and producing a few rough sketches. Work freely—this is a time to brainstorm. Here, the number "25," a cake, and candles have been chosen, and will be written and drawn using masking fluid.

3 When you open the bottle of masking fluid, remove any thick mass floating on the surface. Fill a clean pen with the liquid and move the pen freely and quickly as the liquid will change to the consistency of rubber in just a few minutes. Practice drawing your designs. Once you feel comfortable with your strokes, move on to marking out the invitation.

2 You will be using the masking fluid to draw the candles, cake, and the number "25." So make sure that the liquid is thin enough to flow through a calligraphy pen. Some types of masking fluid are made for watercolorists and the fluid is too thick. To clean your pen, rinse off the masking fluid with water, or if the fluid has dried, carefully peel it off.

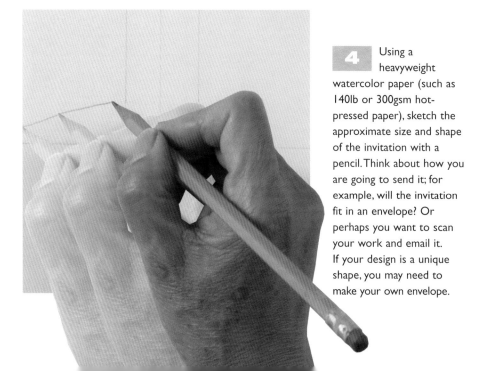

4 Using a heavyweight watercolor paper (such as 140lb or 300gsm hot-pressed paper), sketch the approximate size and shape of the invitation with a pencil. Think about how you are going to send it; for example, will the invitation fit in an envelope? Or perhaps you want to scan your work and email it. If your design is a unique shape, you may need to make your own envelope.

19 To make the leaf prints, gather some medium-sized and small leaves with a pronounced vein structure. Place the leaves between sheets of paper towels and press flat under some books or other weight.

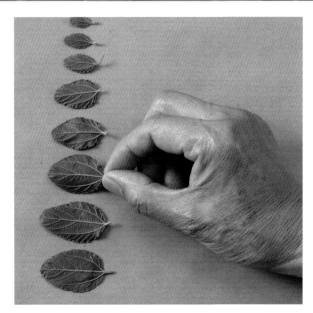

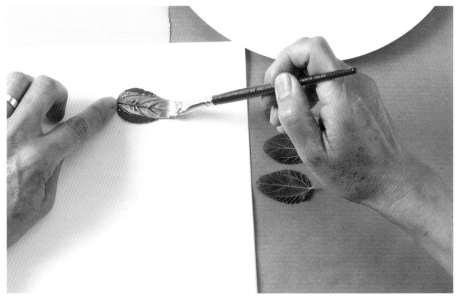

20 Squeeze some yellow and green gouache onto a palette or plate. Add some metallic gouache or gold powder and gum arabic. The paint needs to stay very thick for the leaf prints, so do not add water.

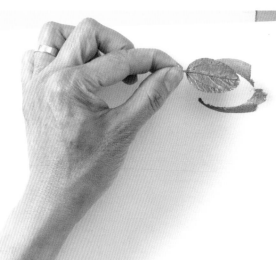

21 Lay a leaf upside down on a piece of scrap paper. Using a brush or sponge, apply paint onto the leaf. If the leaf repels the paint, wash it with soapy water, dry, and apply paint again.

22 Lift the leaf off the paper and make a test print to check the color and amount of paint being applied. Many leaves can make two prints before needing more paint.

5 Once you have decided on the basic proportions, use a T-square and triangle (set square) and draw some guidelines to indicate the size of the card, the position of the candles, the cake, and the number "25." To save time, draw more than one design at a time. In this project, three cards will be made together.

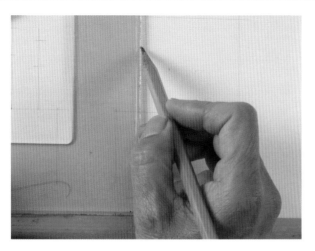

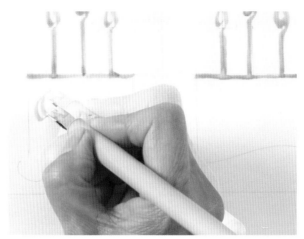

7 For the numbers "2" and "5," a two-line Automatic lettering pen, such as the No. 9 or equivalent, works well; the double lines add emphasis to the numerals. Underneath the candles, write the numeral "2," beginning the first part of the stroke at about 11 o'clock on the clockface and finishing at 1 o'clock.

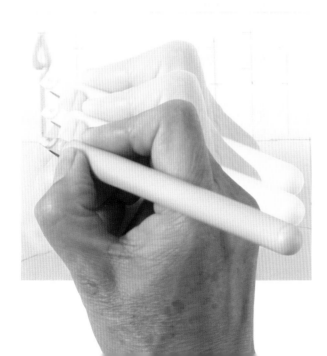

6 Fill an Automatic pen No. 2 or equivalent with masking fluid. Check that the pen point is working by writing on a piece of scrap paper, then draw the candles. With larger pens, it is best to write by pulling the pen with your whole arm (rather than just moving your hand) and write on a flat, or slightly angled, table.

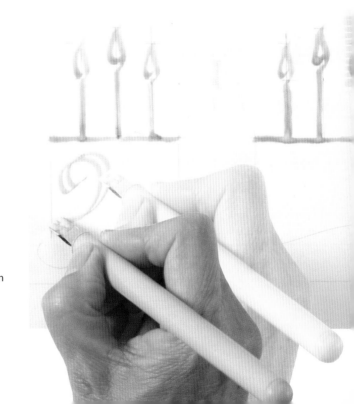

8 For the next stroke, start again at exactly where the first stroke left off. Write clockwise, to 7 o'clock.

16 Use the next-smaller-size pen point to write the next generation of grandchildren and their partners. Reposition the paper so that your hand is comfortably positioned in front of the writing.

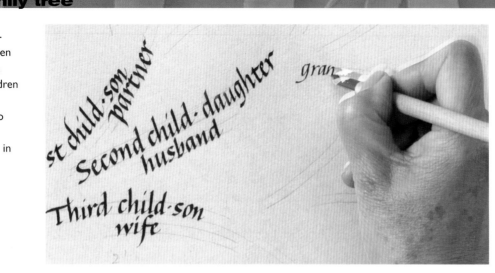

17 No matter how small the writing, the pen needs to be held at a consistent angle to maintain the same vertical strokes. This photograph shows the hand moving to make the second stroke of the letter "g."

18 Now all the writing is complete. Always proofread the words for spelling and other mistakes. Take care that all the writing is completely and thoroughly dry before erasing the pencil lines with a soft eraser.

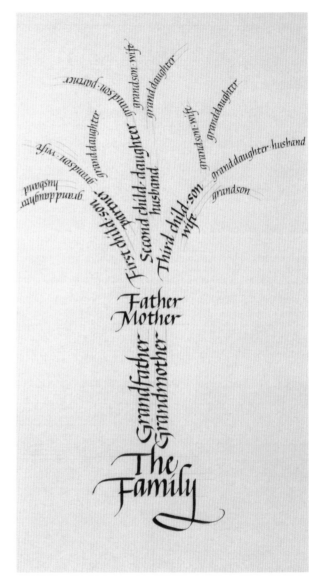

9 The bottom stroke of the "2" requires moving your whole hand to the right. The baseline of the numeral is not horizontal but dips downward slightly.

11 When writing the numeral "5," begin with the downstroke, then push the pen around to finish the bottom stroke. If the pen begins to resist moving smoothly to the left as it comes around the curve, stop writing and lift the pen. Place the pen at the end point of the curve, then pull it back to meet the first stroke.

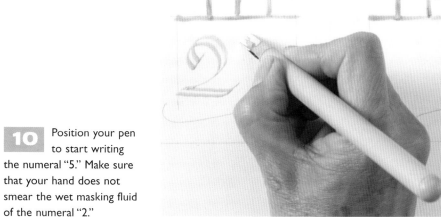

12 After the bottom stroke is complete, lift the pen to fill in the top stroke. Pull the pen to the right to finish the numeral. Many large pens flow more smoothly when pulled rather than pushed.

10 Position your pen to start writing the numeral "5." Make sure that your hand does not smear the wet masking fluid of the numeral "2."

12 When writing on a curve, it is difficult to write all the letters consistently, as this photograph shows. Practice and warm up using the same pen, ink, or paint and paper as you intend to use on the final piece.

13 Check to make sure that you are using the correct size of calligraphy pen. When writing smaller letters, make sure that all the lines are crisp and very thin by removing the pen pressure at the end of a letter to create a fine hairline serif.

14 In certain situations, where there are no ascenders or descenders—such as between the upper line of "child son" and the lower line of "partner"—the space between the lines may be brought closer together.

15 The ascenders on the word "husband" have been written quite short in order to pack the lines together. Here, you can see the finishing vertical stroke of the letter "d."

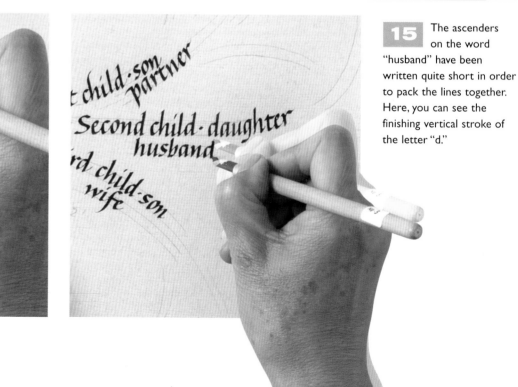

13 Move on to writing the number "25" on the two other designs. Try to maintain an even, thick application of masking fluid as you write. Don't worry if the calligraphy varies from one design to another. This is what gives your work individuality.

14 Next, using the Automatic pen No. 2 or equivalent, draw the vertical lines to form the sides of the cake. Drawing the vertical lines after the numerals have been written makes it easier to center them in the cake—you can be a little flexible as to where exactly you position your lines. Note that on the numeral "5," the horizontal cap extends over the line to help link the design together. The baseline on the numeral "2" extends as well.

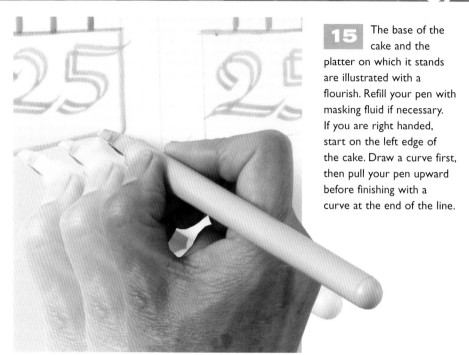

15 The base of the cake and the platter on which it stands are illustrated with a flourish. Refill your pen with masking fluid if necessary. If you are right handed, start on the left edge of the cake. Draw a curve first, then pull your pen upward before finishing with a curve at the end of the line.

16 Mix some watercolors together to make two washes. Test the colors to ensure that one is a few shades darker than the other. Here, two blue washes have been used.

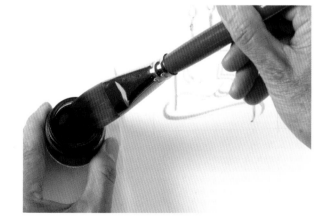

8 Before writing on the selected paper, always practice writing the calligraphy using the same pen, ink, or paint on a sample of the same paper that you will use for the final piece. When you're ready, start writing.

10 Return the paper to the upright position. Using the next-smaller-size pen point, write "Father" and "Mother."

11 Here, the final line of the letter "r" is extended into a flourish simply by moving your hand to the right.

9 After you have written "The Family," change to the next-smaller-size pen point and rotate the paper 90 degrees to write "Grandfather" and "Grandmother," which make up the "trunk" of the family tree. Here you can see the finishing stroke of the letter "G." Note that the pen point size is marked on the penholder.

17 Check to make sure that the masking fluid is completely dry. Fill a wide, soft-hair brush with the darker of your two washes and, starting from the top, pull the loaded brush lightly downward past the edge of your design.

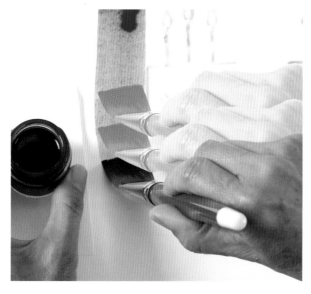

19 Make sure that each stroke of the brush overlaps slightly with the previous stroke, or you will end up with white lines between the strips of wash.

18 Fill the paint brush again with the same wash and, beginning at the base, pull the brush upward to create a strip of color next to the first. Alternatively, you can apply the wash horizontally from left to right, then right to left.

20 Keep applying the wash using this up-and-down method, making sure that all the edges of the masking fluid are painted. Notice the subtle color variations from stroke to stroke. These are a desirable feature, so don't try to retouch any fainter strips—this will only result in a puddle of paint.

4 To write words on a curve, first draw a curve or, if you prefer, two curved parallel writing lines. Move the paper so that your writing hand is positioned comfortably in front of you.

5 Even when writing smaller letters, such as "l" and "d," try to maintain a smooth, flowing writing style.

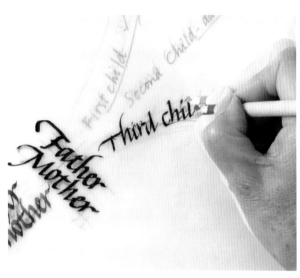

6 Take another sheet of tracing or layout paper to draw the writing lines (tram lines). Fix the paper into position using some masking tape. Use a hard pencil or a ballpoint pen and T-square to draw the lines very carefully and accurately. For the curved lines, hold two pencils together or draw freehand very carefully.

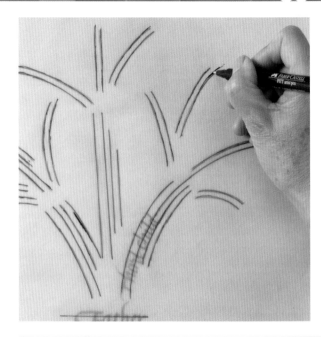

7 To transfer the lines (called "ruling up"), lay a sheet of graphite transfer paper face down onto the paper selected for the finished piece. Use a hard pencil or a ballpoint pen to trace the lines, as well as the first and last letter of the name to help with the positioning.

21 Stop when you have fully covered all your invitations. Be sure to cover the paper beyond the dimensions of the card you marked out earlier. Then allow the paint to dry thoroughly. The heavyweight paper should dry flat with no cockling.

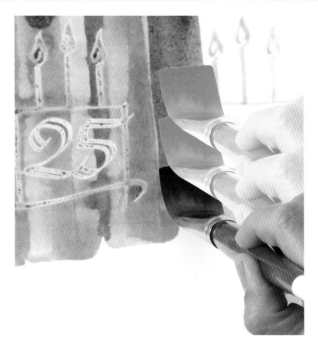

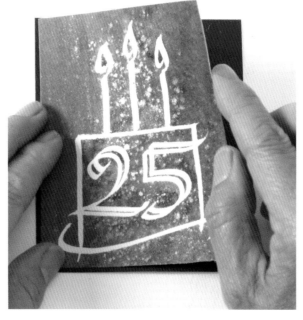

23 Cut out your finished design very carefully using a metal ruler and a craft knife or scalpel, pulling the blade toward yourself. Next, cut out a piece of heavyweight colored paper a little larger than the main design. Use a glue stick or PVA glue to paste the design onto the support card.

22 Next, remove the masking fluid. Here, a pick-up rubber square (available from art shops) has been used to rub the fluid off, but you can also use a piece of masking tape or even clean fingers.

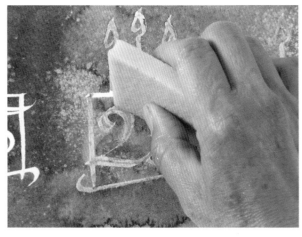

24 Next, make a background design. Fill a William Mitchell pen No. 1½ or equivalent with masking fluid and cover a whole sheet of white watercolor paper with gentle flourishes and pen rhythms. Let the masking fluid dry thoroughly.

1 The illustrated family tree shows the relationships among family members. Using a pencil, sketch onto a sheet of spare paper a working layout approximately the size you imagine the finished piece is going to be. Use the names of your own family members. Proofread them carefully and adjust the layout if necessary to make a final composition.

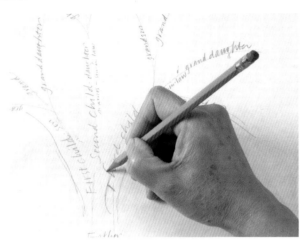

2 Lay a sheet of layout or tracing paper over the pencil sketch and hold it in position with some masking tape. Take a felt-tip marker or a broad-edged pen to write the names in calligraphy. This is not the final calligraphy.

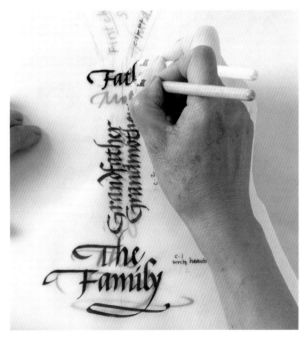

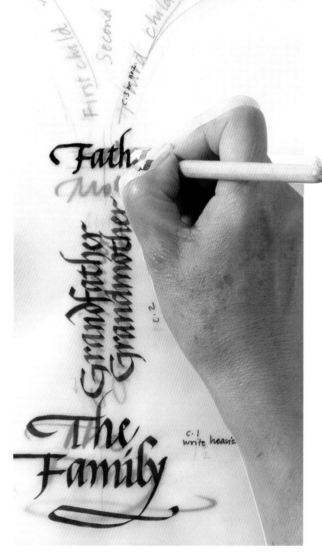

3 With each succeeding generation, the size of the broad-edged pen is smaller. Write the pen point size and brand of pen manufacturer to help you remember which pen you have used for which generation. With family trees, a cut-and-paste method may be helpful when planning the layout.

27 Next, fold in half a piece of the same colored paper used in step 23 to form the card on which the invitation design will be mounted. The front of the card needs to be about 2in (5cm) wider and longer than the cake and candles design. Next, cut out a piece of the lighter, washed paper to a slightly smaller size than the front of the folded card. Use PVA glue or glue stick to paste the two pieces together.

25 Using a wide, soft-hair brush and the lighter color wash you mixed earlier, paint horizontal strokes back and forth across the page until the whole page is covered.

26 Allow the color wash to dry thoroughly. Using the pick-up rubber square, masking tape, or clean fingers, rub off the masking fluid.

28 Glue the invitation design on top of the lighter, washed paper. Check to make sure that everything is glued on straight. Let the glue dry thoroughly. The invitation is then ready to send.

project 5: **family tree**

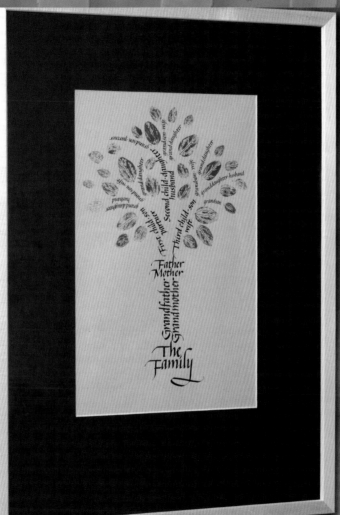

materials

- Archival tape
- Black watercolor paint or ink
- Cheap brush or sponge
- Eraser
- Felt-tip marker
- Good-quality paper
- Graphite transfer paper
- Gum arabic
- Hard pencil or ballpoint pen
- Layout or tracing paper
- Masking tape
- Mat board
- Mat cutter
- Medium-sized and small leaves
- Metallic gouache or gold powder
- Palette or plate
- Paper towels
- Scrap paper
- T-square
- Triangle (set square)
- Variety of broad-edged calligraphy pens
- Yellow and green gouache

project 3: **poem in your pocket**

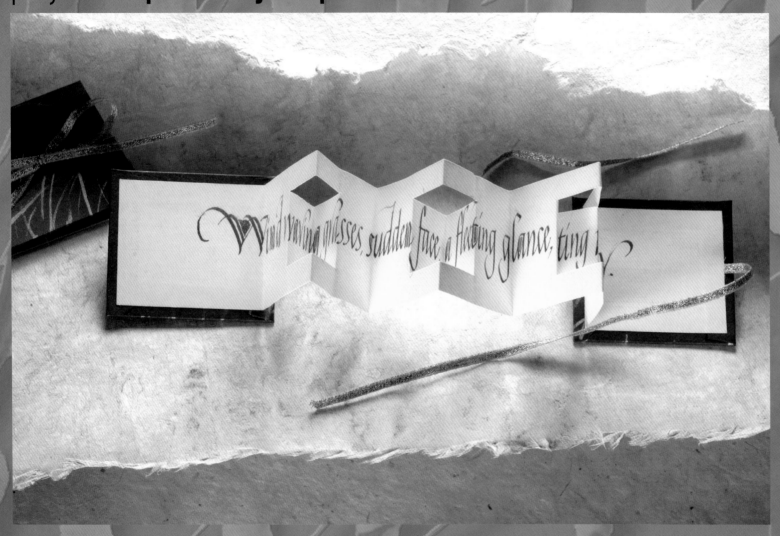

materials

Bone folder
Cheap brush
Cutting mat
Eraser
Gold gouache
Gold ribbon
Ink or gouache
*Light- or medium-
 weight paper in two
 different colors*
*Medium or small
 calligraphy pen*
*Paper towel or
 blotting paper*
Pencil
PVA glue
Ruler
Scalpel
Scissors
Scrap paper
Small, pointed brush
Thin cardboard

22 Smooth out any air bubbles by placing a clean sheet of scrap paper over your calligraphy. Press gradually with the palms of your hands from the center of the sheet to the edges. This will also firmly and evenly paste down your calligraphy to the album cover.

24 Before folding the side edge over the cardboard, use a brush to apply a thin layer of PVA glue to the unpasted corner. Fold the side edge over the cardboard, again using the bone folder.

23 Open the album and use a scalpel to miter the corners of the calligraphy paper, making allowance for the thickness of the cardboard album cover. Fold the pasted top and bottom edges over the cardboard. Use a bone folder to make neat edges.

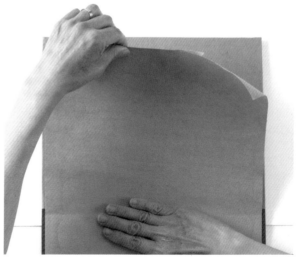

25 Lastly, using scissors, cut some paper to a size just smaller than the album cover and apply a thin and even application of PVA glue. Press the paper flat onto the inside cover to hide the folds and provide a neat finish.

1 Take a large sheet of paper to write on and turn it so that the grain of the paper is vertical (see p. 70, step 18), parallel to the folds of this accordian-style book. Cut a strip of paper about 2in (5cm) wide. To mark the height of the letters and cutting lines, draw four horizontal pencil lines across the middle of the strip of paper. Select a line of poetry or prose and plan where each word will fall.

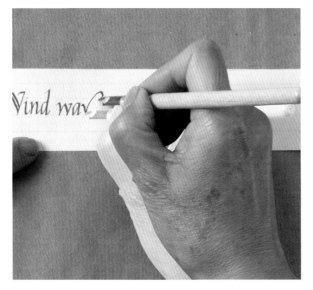

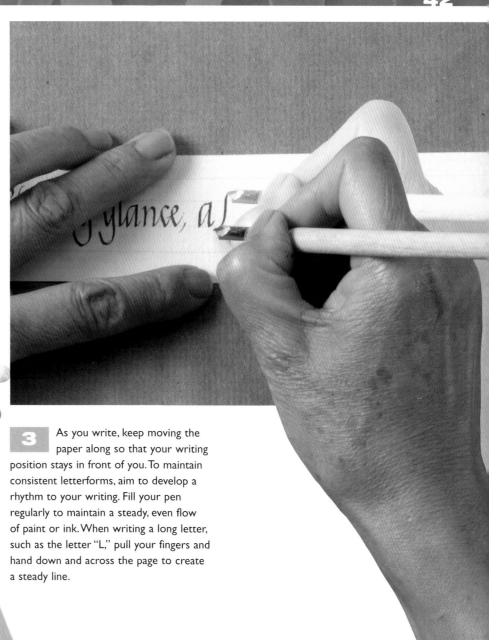

2 You can use any color gouache or ink you like. This project is very flexible and pen and paper sizes are a matter of creative choice. Here, a William Mitchell pen No. 3½ or equivalent is being used. Begin writing about 1in (2.5cm) from the left-hand edge of the paper.

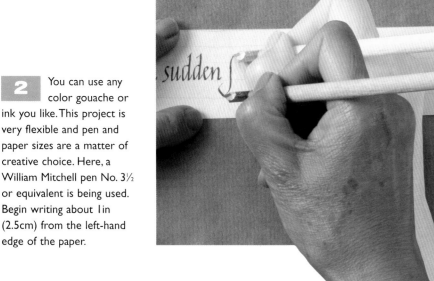

3 As you write, keep moving the paper along so that your writing position stays in front of you. To maintain consistent letterforms, aim to develop a rhythm to your writing. Fill your pen regularly to maintain a steady, even flow of paint or ink. When writing a long letter, such as the letter "L," pull your fingers and hand down and across the page to create a steady line.

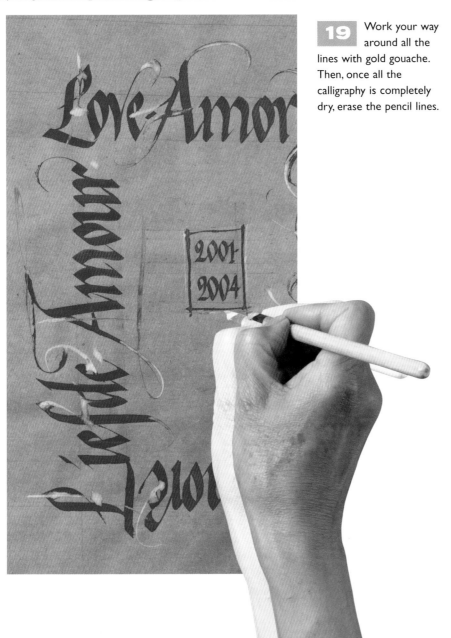

19 Work your way around all the lines with gold gouache. Then, once all the calligraphy is completely dry, erase the pencil lines.

20 Cut out your finished calligraphy, allowing enough space for the top, bottom, and right edges of the paper to be turned around the album cover. Align the paper accurately and mark its position with a pencil. Double-check your marks.

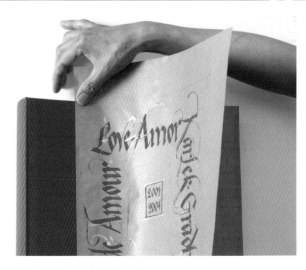

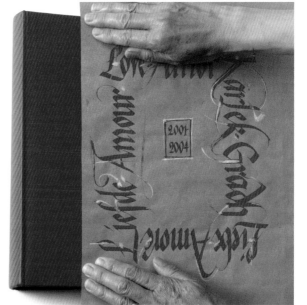

21 Then, apply the PVA glue to the back side of the paper. Test the PVA glue first on a spare piece of the same paper on which the calligraphy is written to make sure that the adhesive does not soak through the paper. Once you are happy with the test, align the edge of the paper with your pencil marks.

4 Write the letter "y" with a flourish. Pull the first stroke downward from left to right and then push it upward like a flourished letter "v." Then, place your pen at the base of the "v" and pull it downward to create the tail of the letter "y."

5 When you have finished writing your calligraphy, let the gouache or ink dry thoroughly. With a cutting mat, metal ruler, and scalpel, carefully cut the paper to a length appropriate to the length of your line of poetry, minding your fingers. If the paper is thick, score several lines with the scalpel along the same groove until the paper is cut through.

6 To embellish your calligraphy, mix some gold gouache to a milky consistency. Fill your pen and add accents to the writing by extending some of the letters into flourishes. In addition, use a small, pointed brush to fill in some selected letters with gold gouache.

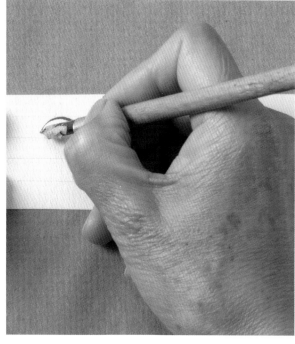

7 Let the paint dry thoroughly. The calligraphy is now complete, with gold flourishes and fill-ins. Check your spelling, but do not yet erase the pencil lines.

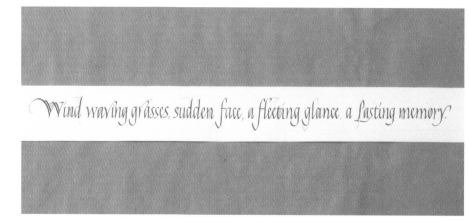

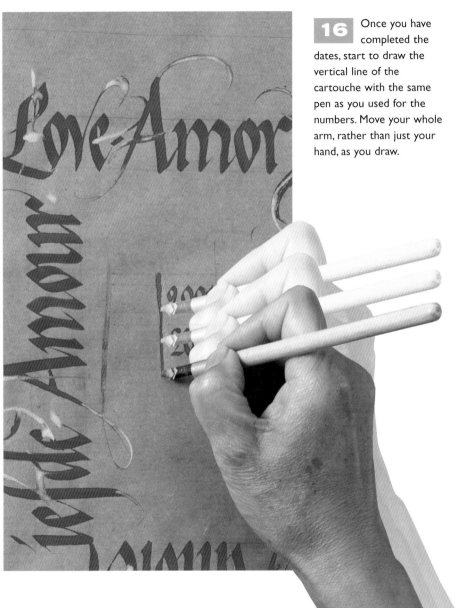

16 Once you have completed the dates, start to draw the vertical line of the cartouche with the same pen as you used for the numbers. Move your whole arm, rather than just your hand, as you draw.

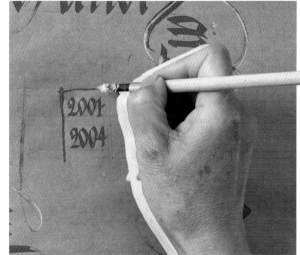

17 Here, the lines are drawn freehand. This means that they will not be perfectly straight. If you do not like this effect, you can use a ruler to make a straight line.

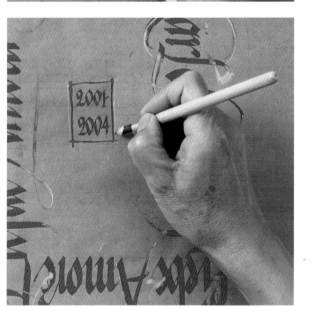

18 When you have finished drawing the cartouche, wash out your pen, then fill it with a little gold gouache. Start to embellish the red cartouche.

8 Next, fold the strip of paper like an accordian. Turn the paper face down, then fold it in half. Open the paper again and take one end to the center crease and fold. Turn the paper over again and take the end to the quarter-fold line and fold again. Fold this over twice more. Repeat on the other side; the strip is folded in eight.

10 Next, make some decorative paper to cover the cardboard. Choose a light- or medium-weight paper and check that the grain is vertical. With some gold gouache and a small, pointed brush, draw some light lines to represent grasses moving in the wind. Start from the base and make an upward movement to create each grass blade.

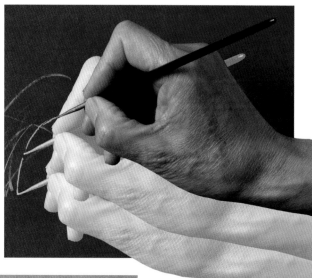

9 Close the folded paper flat. For the book cover, select a piece of thin cardboard and turn it so the grain is vertical. Measure and cut two pieces about 1/4in (6mm) wider and longer than the folded paper.

11 Cut the gold-brushed paper into squares about 1in (2.5cm) wider and longer than the cardboard.

13 Once you have finished the large writing, take a piece of scrap paper and practice writing the dates cartouche. A William Mitchell pen No. 1 or a Speedball C.2 or equivalent is used here and filled with red gouache. Cut out the cartouche from the scrap paper and use it to decide where to position the dates on the cover design. Then, mark this position.

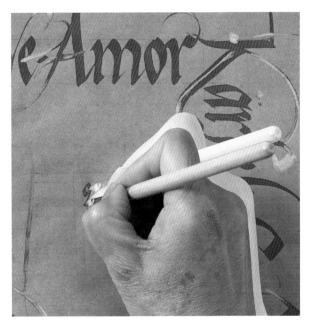

14 Writing the numeral "0" uses the same technique as writing the letter "o." The basic shape of all the letters and numerals in this alphabetic hand is a pointed diamond.

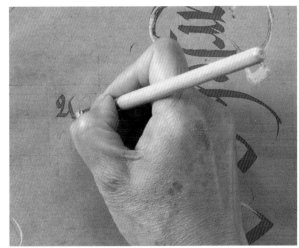

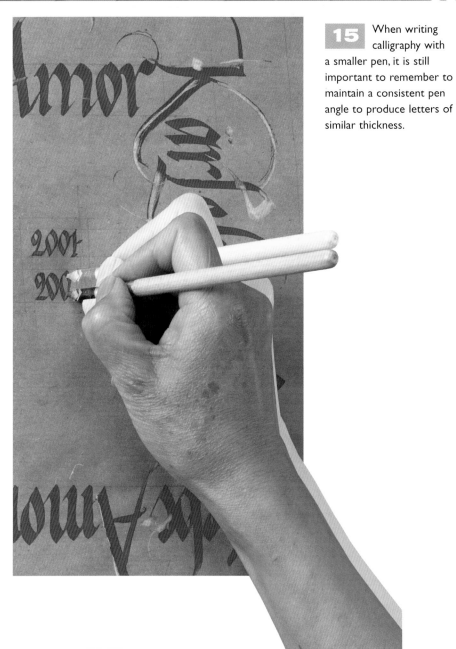

15 When writing calligraphy with a smaller pen, it is still important to remember to maintain a consistent pen angle to produce letters of similar thickness.

12 Turn the decorated paper over and place the cardboard in the center. Using scissors, cut the corners of the decorated paper to about 3/8in (1cm) from the corner of the cardboard. Repeat this whole step on the second piece of decorated paper.

13 Next, put a sheet of scrap paper on the table. Place the decorated paper face down, and apply a thin, even layer of PVA glue, beginning in the middle of the paper and brushing toward the edges.

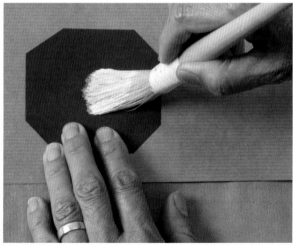

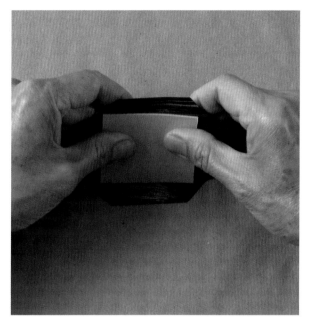

14 Position the cardboard in the middle of the glued paper and press it firmly into place. Make sure the cardboard is centered.

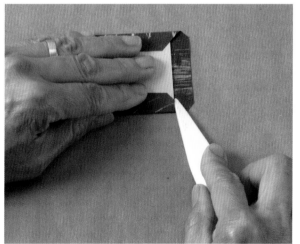

15 Using the bone folder, fold the long edges back. Push the paper toward the center to make a neat edge. Add a little glue to each corner where the paper overlaps. Then, repeat with the short ends. Turn the cover over and place a sheet of scrap paper over it. Smooth out any air bubbles by pressing with your fingers from the center to the edges. Repeat on the other cover.

9 The letter "o" is a two-stroke letter. Begin the first stroke at the top, moving the pen counterclockwise to the baseline. Place the pen back at the top and begin the second stroke, pulling the pen down in a clockwise direction until it meets the baseline, resulting in a diamond-shaped letterform.

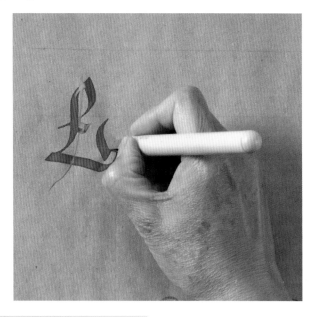

11 These wide, broad-edged calligraphy pens can write letters on their full width or can be twisted to write on their corners. Writing on the corners can produce interesting results, so bear this in mind as an idea for future work.

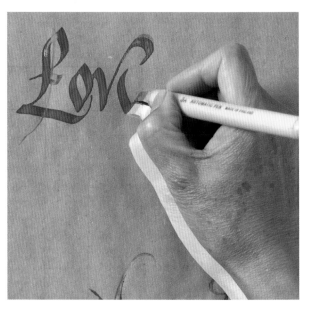

10 Write the letter "v" in a single stroke by pulling the pen downward, then, lightening the pressure on the paper, move the pen upward with your whole arm above the other letters, and end with a flourish. Alternatively, write the letter in two strokes.

12 The flourish on the end of the letter "e" is made by writing on the corner of the pen and pushing it upward to create a fine, thin line.

16 Take about 5in (12.5cm) of gold ribbon, which will form the tie to close the book, and place it on some scrap paper. With the cheap brush, add a little PVA glue to the middle of the ribbon and across the middle of the back of the cover. Place the ribbon in position on the cover. This cover will form the back cover of the book.

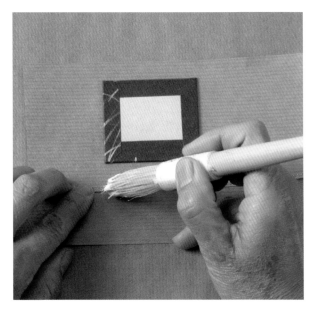

18 Use light, repeated cuts with the scalpel until all the paper is cut through. Always cut slowly and carefully. Repeat the cutting process on the line you marked underneath the calligraphy, taking great care not to let the scalpel blade slip. Then, rub out the pencil lines with an eraser.

17 To cut the reverse pleats of the book, unfold the first and last pages (these will not be cut). Lay the book on a cutting mat. Then, place a metal ruler on the second page, along the horizontal line you marked earlier above the calligraphy. Using a sharp scalpel, make a cut, starting just past the center line of the page. In this book, each page is 2in (5cm) wide, so cut ¾in (1.8cm) to the right-hand edge of the page.

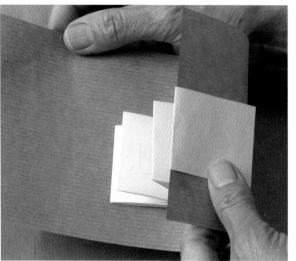

19 Prepare to glue the accordian book to the cover by slipping some scrap paper under the first page of the book. Also, wrap up the rest of the book in the scrap paper. This is to stop any glue from touching the rest of the pages and leaving a stain.

5 The letter "e" is written in two strokes. The first is a pull stroke downward in a counterclockwise direction to form the back curve of the letter. The second stroke begins at the top, and moves clockwise to enclose the head of the letter "e." These letters are based on a diamond-shaped letter "o."

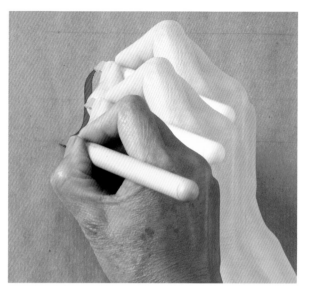

7 When you have finished one side of the rectangle, turn the paper around to begin a new line of writing. Bear in mind that all the flourishes are written beyond the pencil marks you have made.

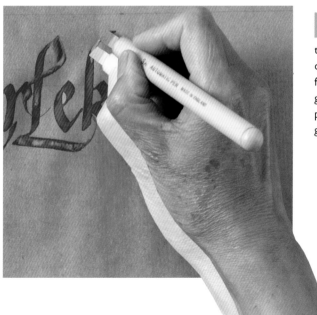

6 Once you have finished writing the letter "k," quickly trace over the red gouache flourish with the gold gouache in your second pen. This will flood gold gouache freely into the red.

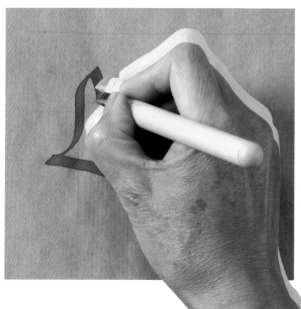

8 The top of the capital letter "L" is similar to the shape of the letter "o" in this pointed alphabetic hand. You will be writing the letter "o" next. Take care that your hand does not smudge the wet paint beneath it.

20 Now the book is completely covered with scrap paper and only the page to be glued onto the front cover is visible. Flatten the book and double-check that the correct page is being glued onto the back of the front cover and that the cover design is the right way up.

21 Using the cheap brush, apply a thin layer of PVA glue to the page. Begin at the folded edge and pull the brush toward the cut edge. Make sure that the edges are completely covered with paste.

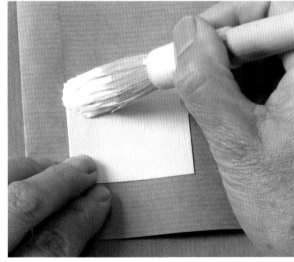

22 Remove the scrap paper and quickly place the glued page squarely onto the inside front cover. Take care that the dampness of the paste does not smear the calligraphy.

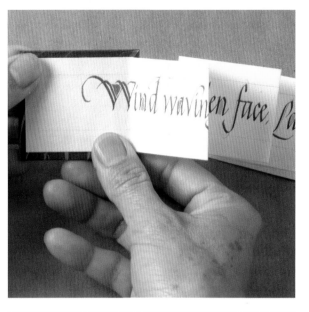

23 Repeat steps 19–22 to fix the back page to the inside back cover. Then, check that both front and back covers align from corner to corner.

1 Using a pencil and T-square, mark the dimensions of your parcel or craft paper. It should be big enough to wrap over three of the edges of the cover, with the left edge cut to meet the red binding cloth. With a pencil, draw writing guidelines to form a rectangle around the cover. Choose your words (here, the word "love" is used in many languages), and work out where they will fall.

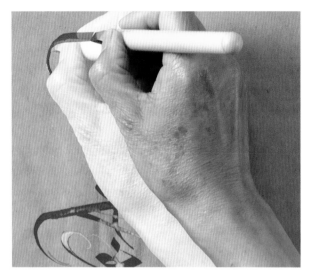

3 The letter "K" is finished with gold linear decorations parallel to the vertical stroke. To write the letter "a," lift your pen to make a steep diagonal upstroke within the letter and finish with a vertical downstroke.

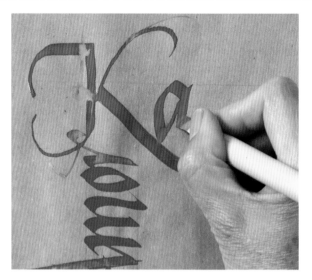

2 Mix red and gold gouache in separate palettes. Using a cheap brush, fill one of the Automatic pens with the red gouache, and start writing. Use flourishes for some letters, such as the capital letter "K." Move your whole arm to write the horizontal flourish and the vertical line, then push the pen upward for the diagonal stroke.

4 When writing the letters, try to maintain a consistent pen angle by moving your whole arm rather than just your hand. Keeping the pen at a consistent writing position ensures that strokes such as the letter "l" have the same thickness from the top to the bottom of the stroke. This also applies to the two, short parallel strokes that form the umlaut on the letter "a."

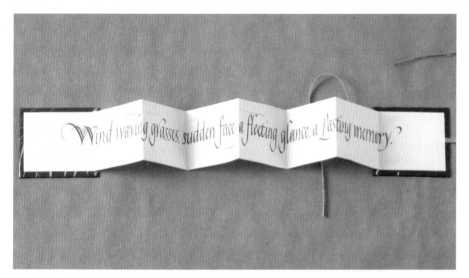

25 To fold the reverse pleats, press the inner cut slits with your finger in the opposite direction to the main folds. Repeat on each reverse pleat.

26 The finished accordian book has a striking inner zigzag of reverse pleats in contrast to the main folds. Tie the ribbons in a bow to close the book.

24 Allow the glue to dry. The paper and cardboard will tend to curl slightly as the glue dries. To stop moisture getting to the rest of the pages, place a piece of paper towel or blotting paper between the damp front and back folds and the rest of the book. Press the whole folded book between some magazines overnight to iron out any curls. Then, open the book.

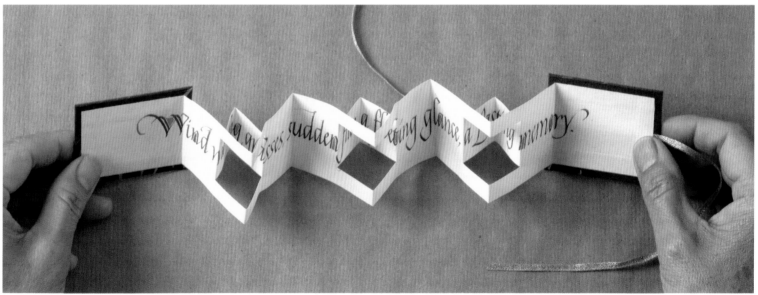

project 4: **photograph album cover**

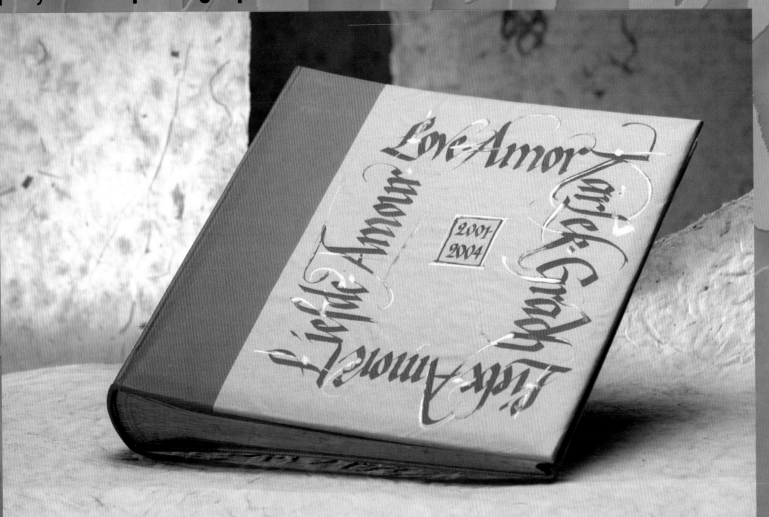

materials

2 identical Automatic pens No. 3A (¼in/ 6mm) or equivalent

2 palettes

Bone folder

Brown parcel paper or brown craft paper

Cheap brush

Eraser

Pencil

Photograph album

PVA glue

Red and gold gouache

Ruler

Scalpel

Scissors

Scrap paper

T-square

William Mitchell pen No. 1 or 3mm or equivalent, or Speedball C.2 or equivalent